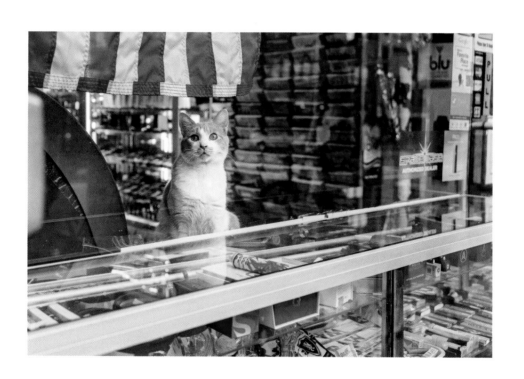

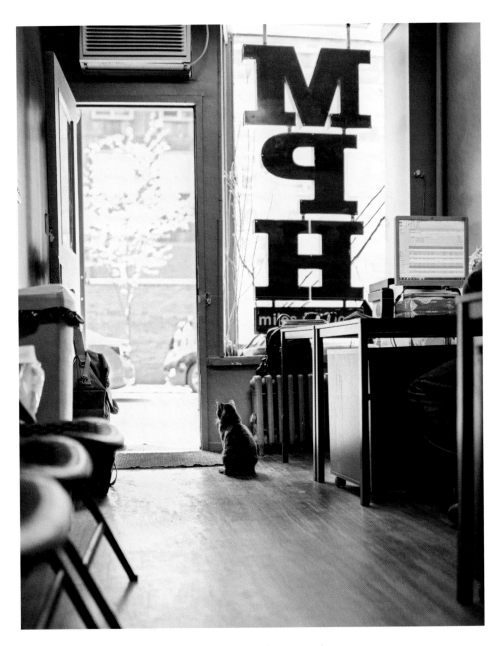

To Kip, Petie, Haddie, and Haroun

SHOP CATS

OF NEW YORK

TAMAR ARSLANIAN
PHOTOGRAPHY BY ANDREW MARTTILA

HARPER
DESIGN
An Imprint of HarperCollinsPublishers

Contents

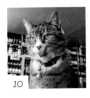
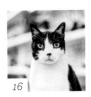
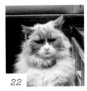
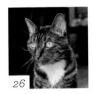
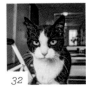
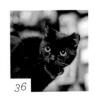
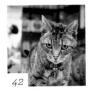
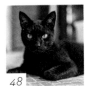
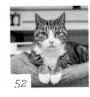
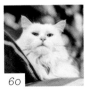
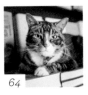
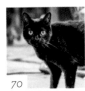
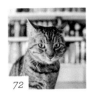
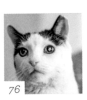
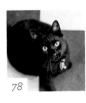
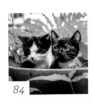
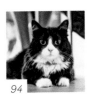
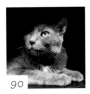

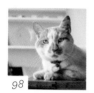

98

Jasper
FLICKINGER GLASS
Red Hook,
Brooklyn

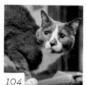

104

Hampton
CORNER BOOKSTORE
Upper East Side,
Manhattan

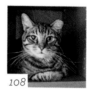

108

Campus Cats
PRATT UNIVERSITY
Clinton Hill,
Brooklyn

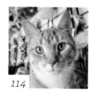

114

Max
PETS ON THE RUN
Astoria,
Queens

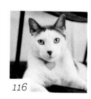

116

Valentino
CARROLL GARDENS REALTY COMPANY
Carroll Gardens,
Brooklyn

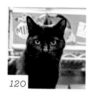

120

Molly
MYERS OF KESWICK
West Village,
Manhattan

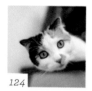

124

Bud
CHENILLE CLEANERS
Midtown West,
Manhattan

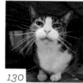

130

Boots
FOLIAGE FLOWERS
Flower District,
Manhattan

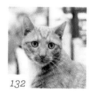

132

Lionel
RED CABOOSE
Midtown,
Manhattan

136

Chloe
WEST CHELSEA VETERINARY
Chelsea,
Manhattan

142

Cats for Adoption
MEOW PARLOUR
Lower East Side,
Manhattan

146

Charlie
SMOKE SCENE
Hell's Kitchen,
Manhattan

148

Tiger
QUALITY BOWERY
Bowery,
Manhattan

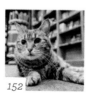

152

Harriett
SHAKESPEARE & CO.
Upper East Side,
Manhattan

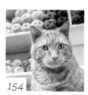

154

Ric and Rac
DAYTONA TRIMMINGS
Garment District,
Manhattan

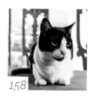

158

Allegra
C.O. BIGELOW
West Village,
Manhattan

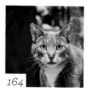

164

Sava
DREAM FISHING TACKLE
Greenpoint,
Brooklyn

168

Bobo
JAPAN MARKET INC.
Chinatown,
Manhattan

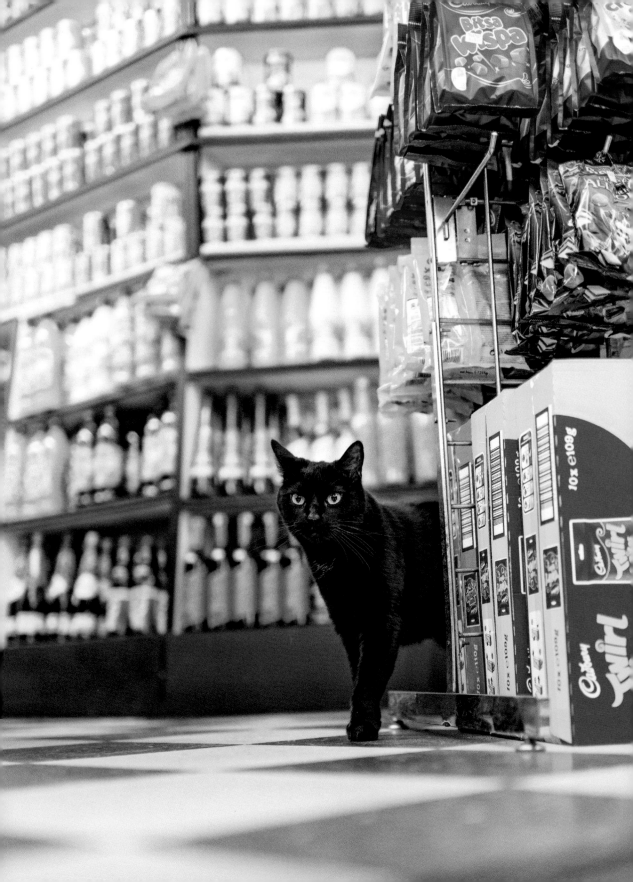

Introduction

Life in New York is all about magic moments of discovery. Finding something wonderful others may not know about or notice. One microcosm of New York City is that of the shop cat.

As a cat lover, writer, blogger, and cat parent to three rescue cats, it was only natural I noticed cats wherever I went. My first encounter with a shop cat was Jack at my local wine store. A kitten when I first came across him living in a wicker basket by the register, Jack is now an adult on a low-calorie diet who rivals the register in size. He can often be found on the counter as if manning the shop, critically assessing customers' wine selection.

As I started meeting cats in various shops around my neighborhood, I wanted to know where I might find others throughout the city. Convinced a book or an online accounting of these cats must already exist, I went directly to Google and was surprised to find very little both on- and offline about the shop cats of New York City. The information I dug up was limited, leaving me wanting more.

I had to assume I wasn't the only one curious about the cats of New York City. And upon finding so little on the subject I could not believe my good fortune. After wanting to write a book and struggling with a topic for so long, it was obvious I would have to write a book that did justice to the shop cats of New York. Now all I had to do was find a photographer who could capture felines and their personalities while still showing them in the context of their everyday New York City lives.

When I met Andrew Marttila (at a cat event—where else?) and saw his work, I knew I'd found "the one" to bring my stories to life. His work is like none other. Andrew has a way of creating a bond with each of his subjects that translates to his photographs, making them intimate and bringing out the unique character of each feline.

I must admit that before getting to know Jack and the other cats in this book, I felt bad for felines who lived out their days in businesses. Not only did I wonder if they were being used merely as marketing gimmicks, I pitied them, thinking they'd be better off in more traditional living situations. I was saddened at the thought of them spending their evenings alone while I was home doting on my felines.

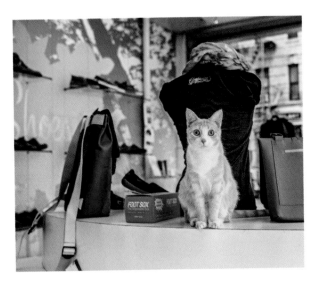

However, as I spent time with these cats (and their humans), I noticed they were extremely well taken care of—spoiled even—and adored, not only by the employees but also by the clientele. In writing this book, and speaking to shopkeepers, I came to realize these cats received much more love, attention, and stimulation than the average apartment cat—including my own—who spends most of the day alone, seeing his or her guardian briefly before work and again in the evening hours.

The more I looked, the more I found kitties tucked away all over this great city in the most iconic and most mundane of spots: Positioned atop the glorious marble reception desk at the Algonquin Hotel, having the run of a vast whiskey distillery, judging vinyl snobs at a record store, watching my every move at the local Pilates studio—and every place in between. Cared for and loved, belonging to all.

These cats are responsible for creating unexpected relationships, and fostering a sense of community in neighborhoods across the boroughs of this vast city. They provide an avenue for strangers to make connections and strike up conversations, while bringing warmth and humanity to a city that can be cold and lonely.

Many of the shopkeepers we spoke with referred to their shop cats as the "King" or "Queen" of their establishment, casting themselves and their employees as men and ladies in waiting, truly bringing the saying "dogs have masters, cats have servants" to life. When I asked an employee of an upscale dog boutique why they had a resident cat, I was met with the response, "Well, someone has to keep things in order around here."

Many—if not all—of the cats in this book have "fans" who drop by to check on them regularly, some even bringing tokens of affection in the form of a tasty morsel or a toy. These cats thrive in an environment with a constant flow of people to be admired and petted by (and to occasionally swipe at), and potentially even a mouse or two to chase. Not to mention the endless supply of boxes. They are emphatically loved and pampered.

Sadly, not every cat in the city is as well cared for as those we selected for our book. Cats in many bodegas (corner grocery stores) are primarily kept as mousers (rodent control) and sometimes neglected. Shelters and rescue groups are understandably reluctant to adopt cats out to businesses because of these reasons, making it difficult for the cat-loving shopkeepers to adopt through regular channels. We hope this book sheds light on the positive aspect of shop cats, encouraging rescue groups and shelters to open their minds to less traditional homes.

So the next time you're in a New York City shop, look around to see if there's a four-legged King or Queen judging you from a regal feline perch.

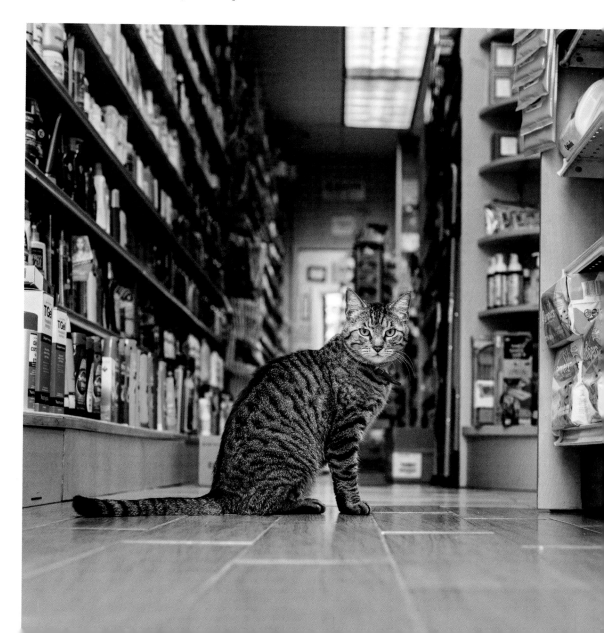

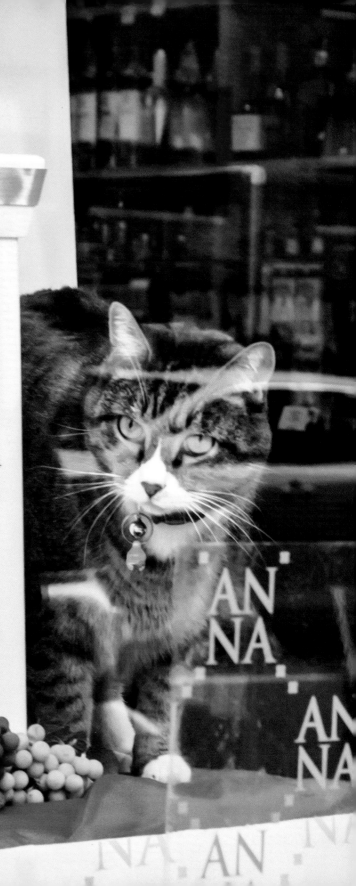

Jack Daniels Bagley

WINE HEAVEN
Gramercy Park, Manhattan
Wine Store

I live a block away from Wine Heaven and had the pleasure of meeting Jack, the resident store cat, as a kitten. Back then there was a wild air about him, and to this day he must be approached gingerly. This is not to say Jack isn't friendly, but he has boundaries.

Jack began life in an apartment vestibule above the wine store where, at the tender age of three months, the building's superintendent discovered him. Lucky for him, the super was a cat man. He picked the ornery kitten up by the scruff and brought him downstairs to the wine store, asking Elizabeth and Caroline, the Irish sisters who own the store, if they'd take the rascal in temporarily.

Given the number of people entering the store daily, the sisters were confident a customer would quickly spot little Jack (who'd taken up residence in a wicker basket by the register) and fall in love with him. And they were right, two people fell in love with him: Elizabeth and Caroline. So the then little Jack and basket stayed put.

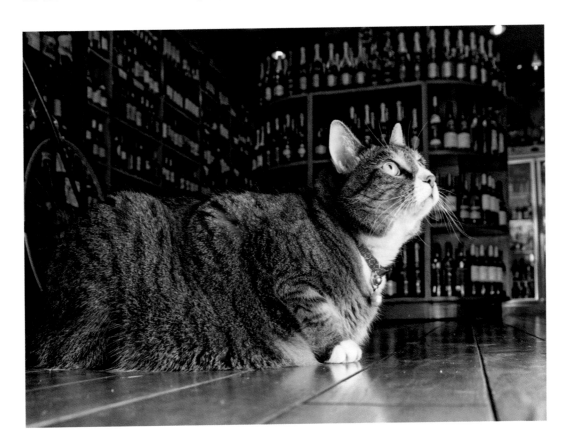

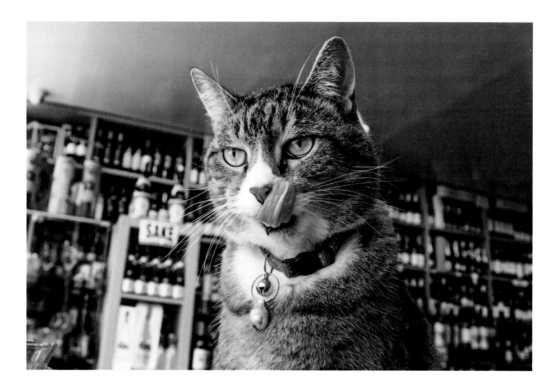

One may go so far as to call Jack spoiled, or perhaps just very lucky. When not in his private loft space or getting a chiropractic adjustment (he has a bad back), Jack can be found lounging on his "Jack Lives Here" doormat as fans come bearing gifts in the hopes of getting on his good side.

Recently, Jack tried—in his own way—to warn the staff of danger lurking nearby. For several days he refused to pass by a particular set of wine shelves, staring at them to a degree that was rather unnerving. The ladies, thinking there might be a rodent, got down on hands and knees to conduct a thorough examination that yielded nothing. A few days later the entire shelving unit collapsed, causing a hailstorm of wine bottles to shatter and resulting in thousands of dollars in lost inventory. They now know to take Jack's stares seriously.

Jack also has quite "the nose," relieving many an unsuspecting customer of catnip from purses and bags placed on the ground. Perhaps in another life he'd have made a world-class sommelier.

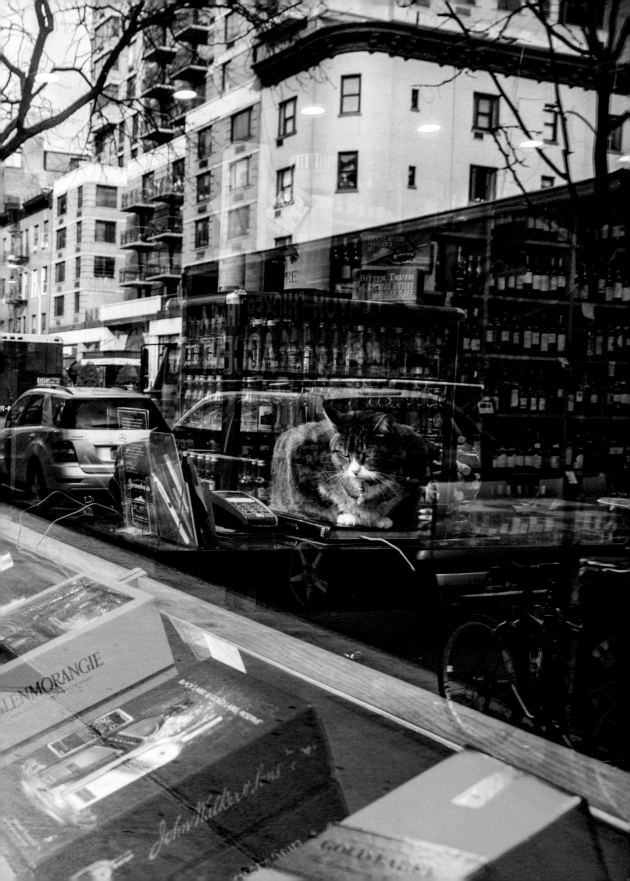

Marlow and Georgie

MOO SHOES
Lower East Side, Manhattan
Vegan Shoe Store

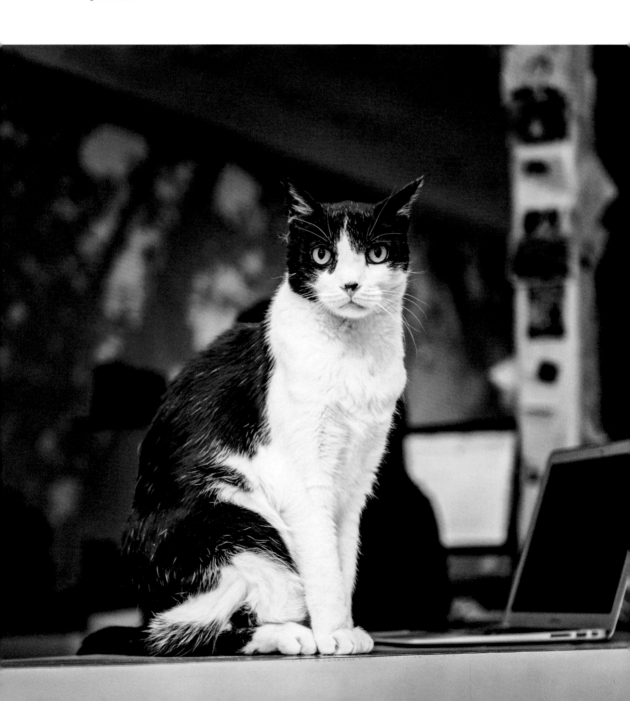

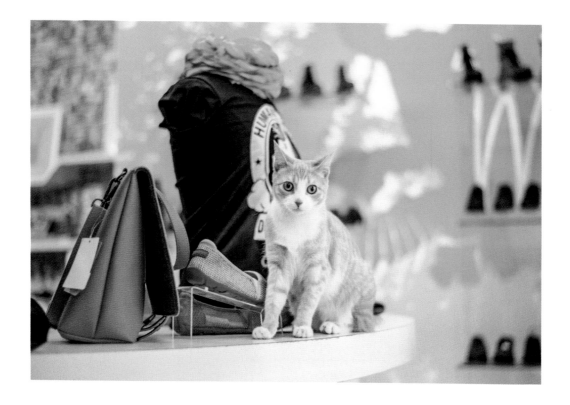

Moo Shoes, a vegan shoe store owned by two vegan sisters, Erica and Sara, has a long history of store cats. One of them, Bowery, was a local celebrity with a large and loyal following whose likeness graces tote bags for sale to this day.

The irony of obligate carnivores in a vegan store was not lost on me and is something with which Erica struggles. "Yes, of course it is a bit of an inner conflict . . . so the least we can do is provide shelter and care for them." But customers don't make the connection, or seem to mind if they do.

Currently, the store is home to two cats, Marlow and Georgie. Marlow, the black and white senior resident, has been described as "statuesque" and "distinguished," and while both are true, I'd add "crotchety" to the list. In his defense, this is a trait he's earned a right to with age.

Georgie, a ginger kitten barely a year old, is the latest Moo Shoes addition. And while cute, she may well be the source of Marlow's somewhat sour temperament. Given her youth, her inability to stay put for more than a few seconds at a time comes with the territory. She doesn't walk or prance, but bounces from one place to another.

Several foster cats were auditioned before one was found that Marlow could tolerate.

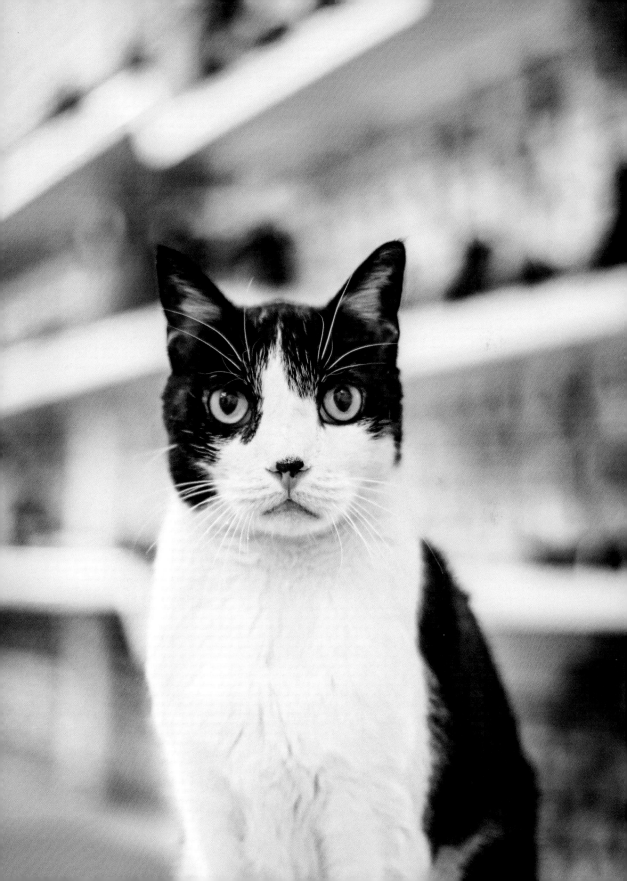

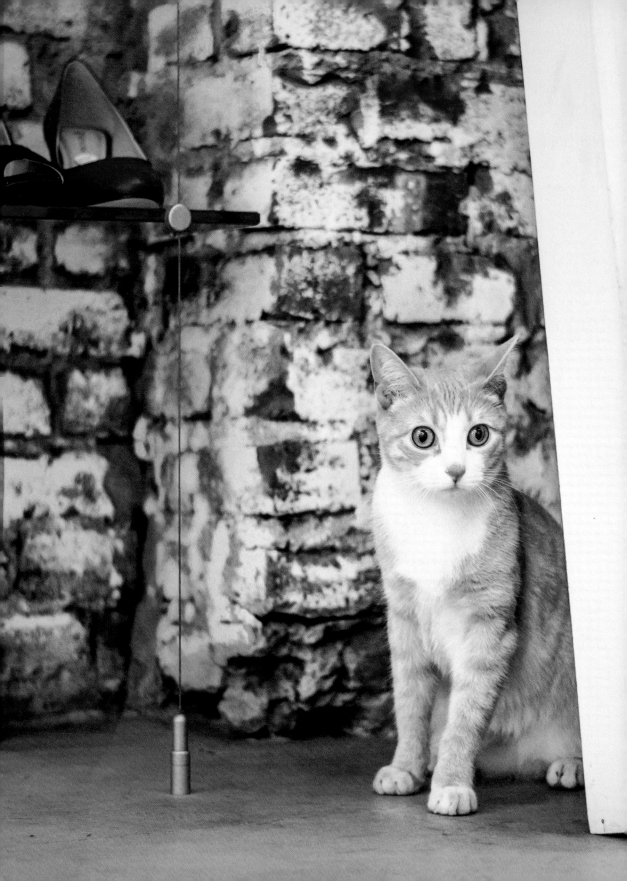

Matilda

THE ALGONQUIN HOTEL
Times Square, Manhattan
Hotel

The Algonquin Hotel—made famous by its Round Table of hard-drinking literary figures like Dorothy Parker—has had a cat-in-residence since the late 1930s when owner Frank Case saw a stray wander into the hotel and welcomed him with open arms.

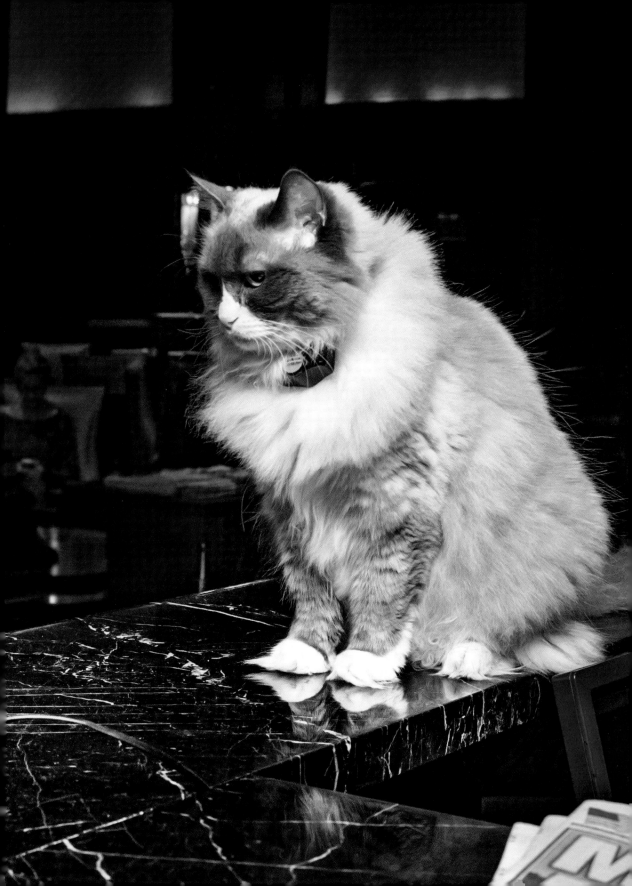

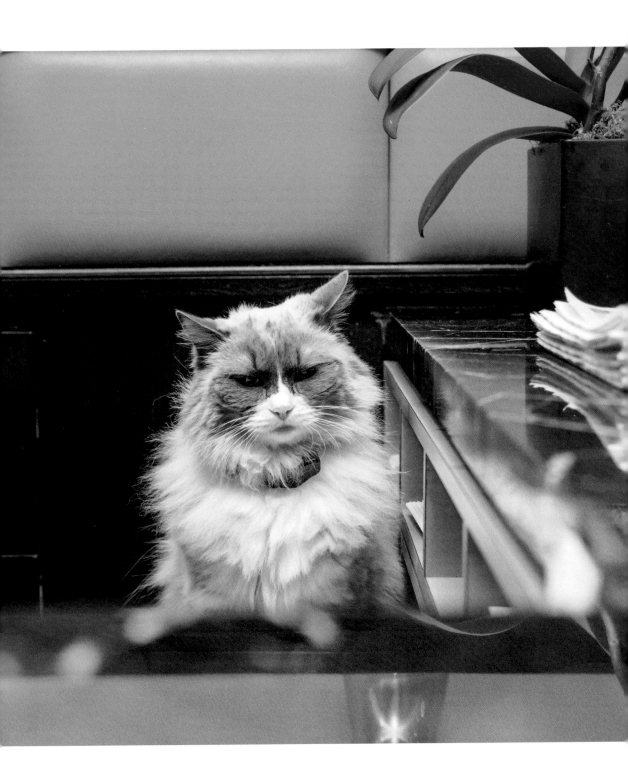

Since then, the hotel has been home to ten cats, all but one a rescue. The males have all been named Hamlet, a tribute to John Barrymore who stayed at the hotel while playing the role on Broadway. The females, three to date, have all been named Matilda, though no one knows—or will reveal—the origin of that name.

Today's Matilda is a rag doll who came from a less than noble beginning, dumped in a box outside North Shore Animal League, a well-known shelter on Long Island. Shortly after being procured from said box, she took her rightful position at the front desk of the hotel in 2010.

Alice Dealmeida is the executive assistant at the hotel and is also Matilda's personal manager, a responsibility not revealed to her before she accepted the position ten years ago under the reign of Matilda II.

As fate would have it, Alice is the perfect woman for the job: mother figure, reputation manager, and gatekeeper. As a public figure, Matilda receives correspondence from around the world. Alice says, "Since she has no thumbs of her own, I have to reply to her e-mails while she sits on my lap."

Alice adds, "As tolerant as she is of visitors, there are times she's just had it and doesn't want to be bothered. She regally sits on the luggage cart, swinging her tail to attract attention from guests, and then strikes a pose—chin in the air just like an Algon-queen should! 'Adore me from afar' is her motto."

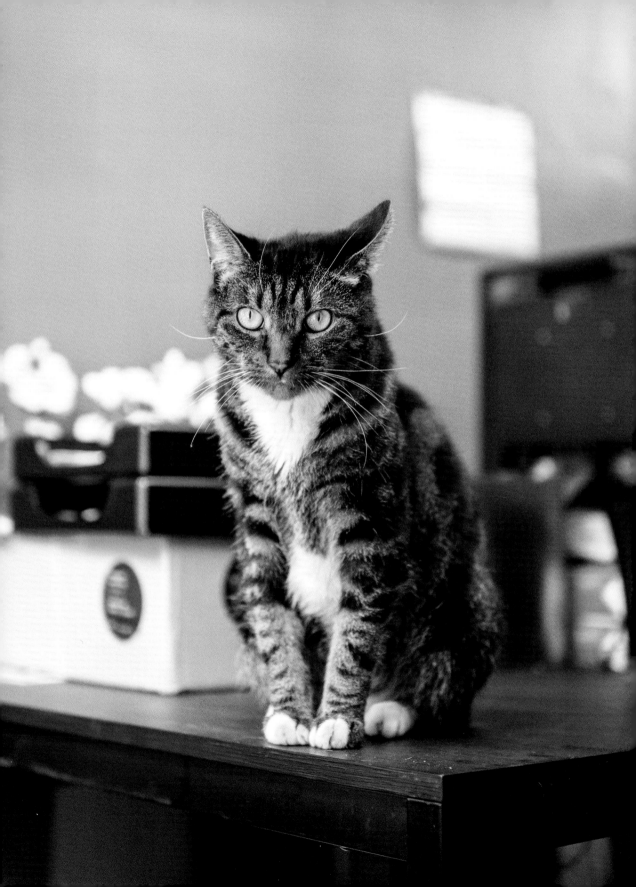

Sammy

MPH
Chelsea, Manhattan
Messenger/Courier Service

MPH is located in a slip of an office, dominated by four large desks each occupied by a strapping man intently focused on fielding multiple calls, while taking orders, and directing lost couriers. *Controlled chaos* is the only way to describe it, and we'd come during their "slow" time.

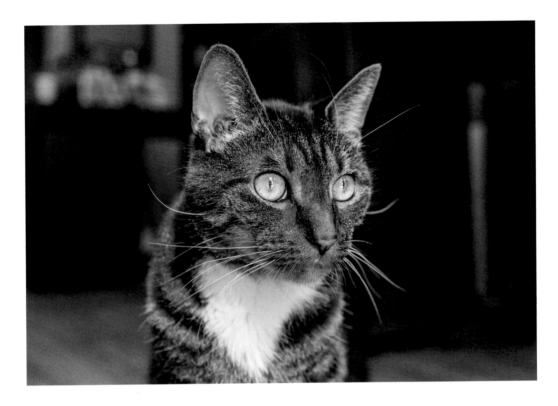

I was hesitant to bother anyone just to ask about a cat, but then I saw him. Sammy the tabby, a beautiful, friendly, bow-legged ten-year-old cat with an unusually reddish hue to his face. He deftly navigated desks cluttered with boxes, phones, computers, keyboards, and smartphones. Every once in a while a large human paw twice the size of his head would absentmindedly reach out to give him a gentle stroke or chin scratch as he made his supervisory rounds.

Not once was Sammy spoken to harshly for his potentially annoying behavior or removed from atop a desk. Not even when he blatantly walked across a keyboard, as cats will do.

Sammy seemed to spend most of his time on the first desk at the front of the office belonging to Cordell, and was "helping" him ("snoopervising") with orders upon our arrival. Cordell chalks that up to Sammy's being a good judge of character, a comment that prompted grunts and snickers from the other men. (Cordell's desk also happens to have a clear vantage point to the goings on outside.)

When I asked the only desk-less guy there if he was security, he nodded in Sammy's direction. "He's security."

According to Terrence, the manager, "Sammy keeps the guys soothed and relieved." Terrence and his brother do TNR (trap-neuter-return) work on their own in the Bronx, though Terrence denies being a cat person. "We're dog people," he insisted. "But we gotta take care of the animals."

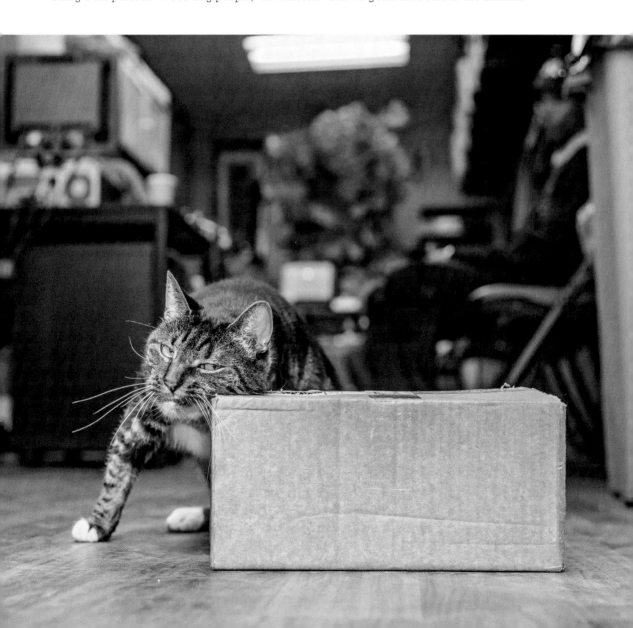

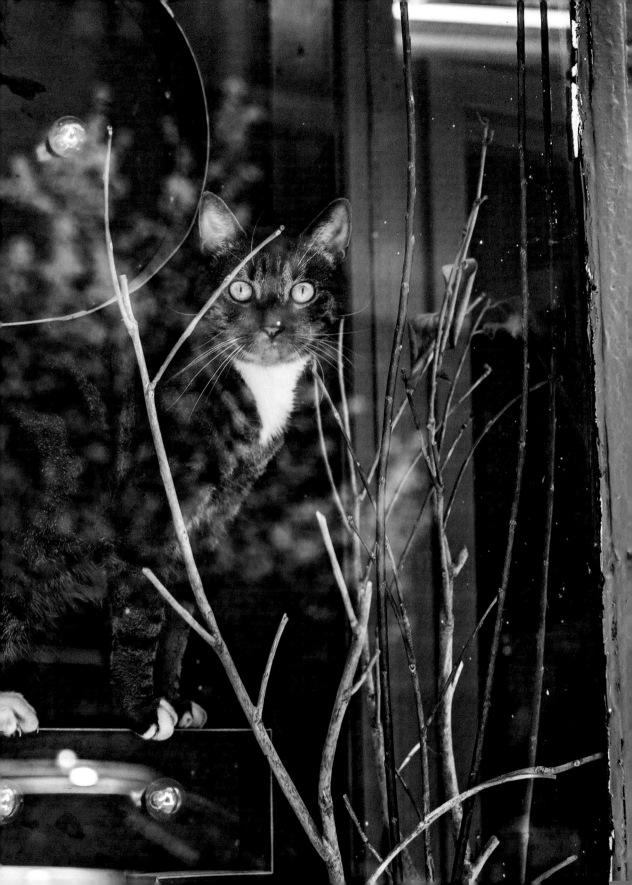

Kitty

SAL ANTHONY MOVEMENT SALON
Union Square, Manhattan
Pilates Studio

Kitty's petite physique and demure manner are rather misleading. Many years ago, Kitty was living in Little Italy where she let herself into a restaurant by way of an open window. I believe that falls squarely within the definition of trespassing. Sal, the owner of the establishment, didn't mind and decided the pretty criminal was welcome to stay.

The cops, however, were not as forgiving seeing as she was a blatant violation of the health code. It's then that Kitty had to "go on the lam." Or so the story goes.

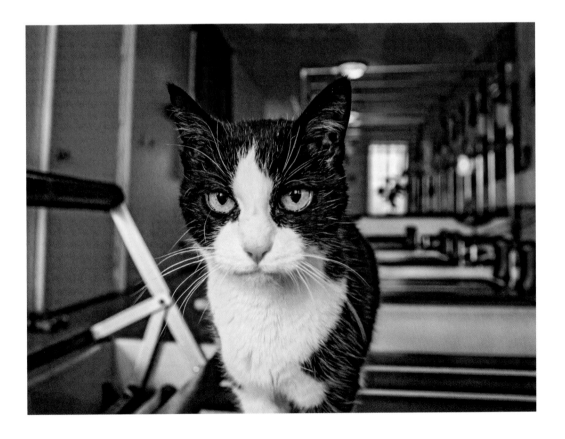

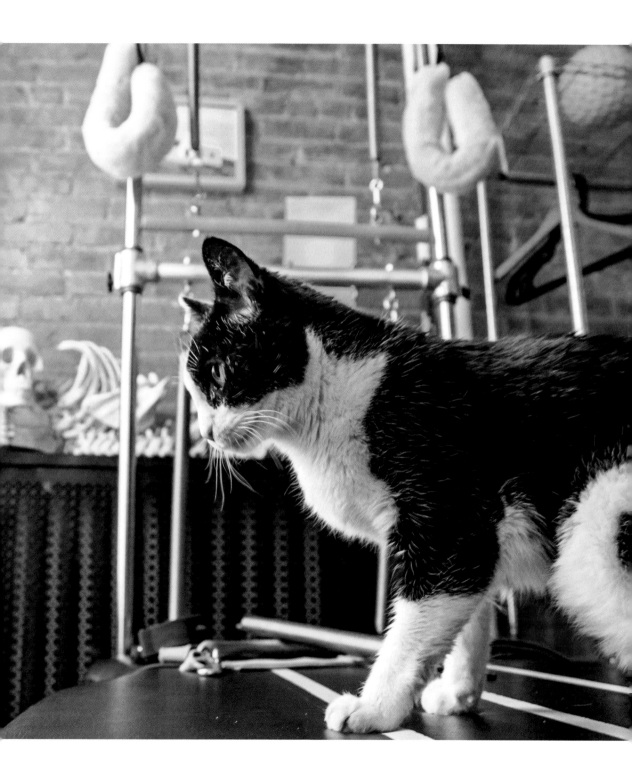

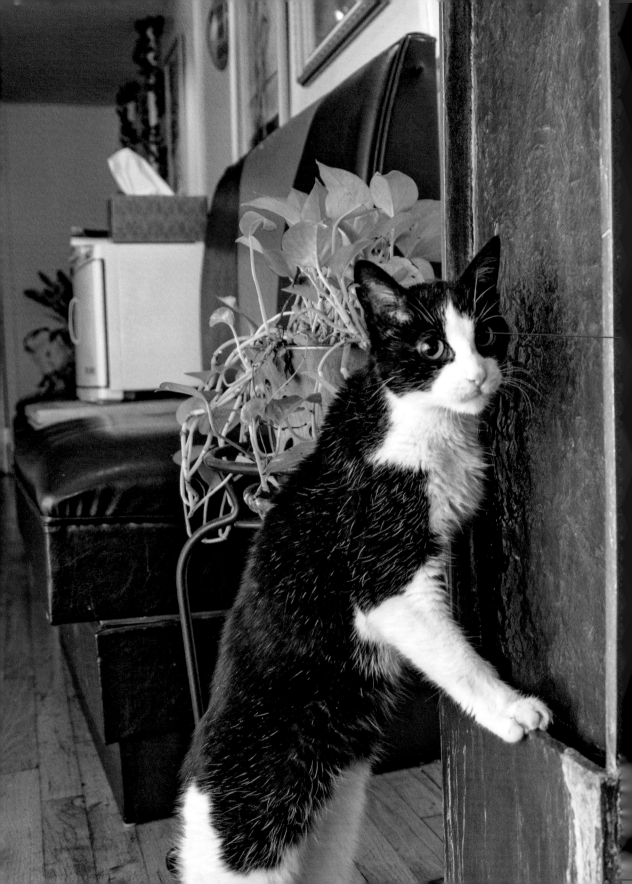

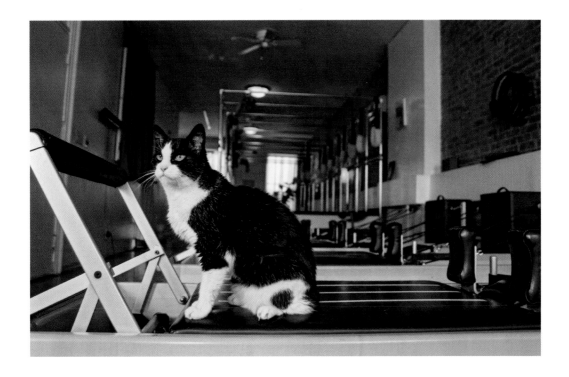

Sal eventually quit the restaurant business, went vegan, and opened a yoga and Pilates studio that became Kitty's new residence. A sassy and adaptive cat, she quickly made herself at home, jumping up onto the Pilates reformers—and the occasional student—during classes.

One of the regular students, a clairvoyant, said that in a former life Kitty was a performer in the exact same building. Given the building's history as a German social hall and beer garden in the late 1800s and a jazz club in the 1970s, who's to say it isn't true? She had a proper name back then, but when asked, it turns out she's perfectly fine with being called "Kitty" in this life.

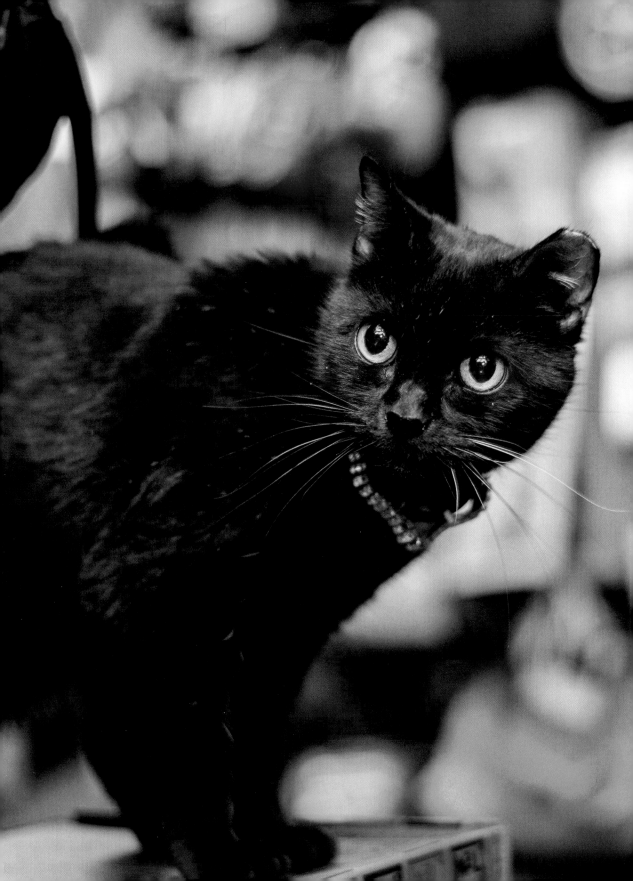

Patti Gucci

TENT AND TRAILS
Financial District, Manhattan
Camping Goods Store

Patti Gucci (a riff on the high-end camping brand Patagonia)
went from living in a feral colony to residing in a camping
shop full of handsome men who dote on her every whim.

A petite, curvy kitty with jet-black fur that sets off her "dia-
mond" collar, she looks more ready for a Gucci editorial
than a day in a camping goods store. When arranging a
time to photograph her, owner Jamie Lipman Abis sent me
me the following e-mail.

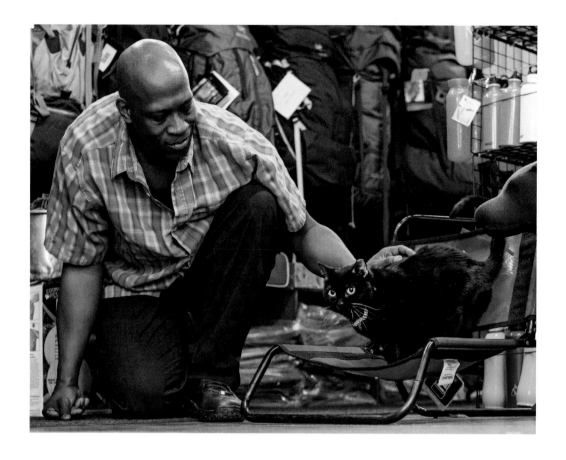

Patti's Thursday schedule is breakfast at 9:00 a.m. and a nap at 9:30 a.m. until she is too tired to nap. Patti Gucci should be available from 9:45 a.m.–6 p.m. but requires pre-approval of any published photos. Feel free to give Patti an advance list of your questions to vet before her interview. Oh, did I forget to mention she wants premium Colorado gold nip.

I was starting to get concerned until I spotted the "lol" at the end of her note.

It seems Patti was not getting along with the other feral cats in the colony but also proved to be a challenge in foster care (her diva-like sensibilities were honed at an early age). The stars aligned for this picky kitty when Jamie began looking for a new shop cat and their paths crossed.

The store's website lists her official title as "Customer therapist, assistant buyer and HR," though she has additional responsibilities modeling for brochures and handling social media responsibilities, tweeting sage camping advice such as *"Remember, you don't have to outrun the bear, you just have to outrun your relatives."*

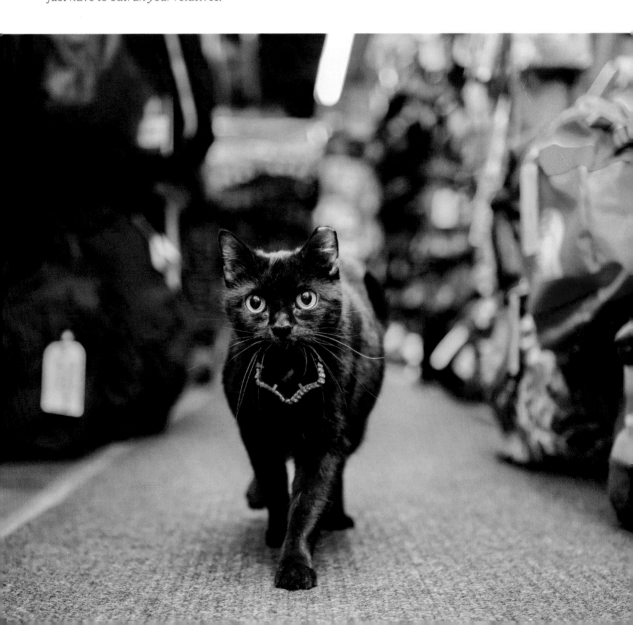

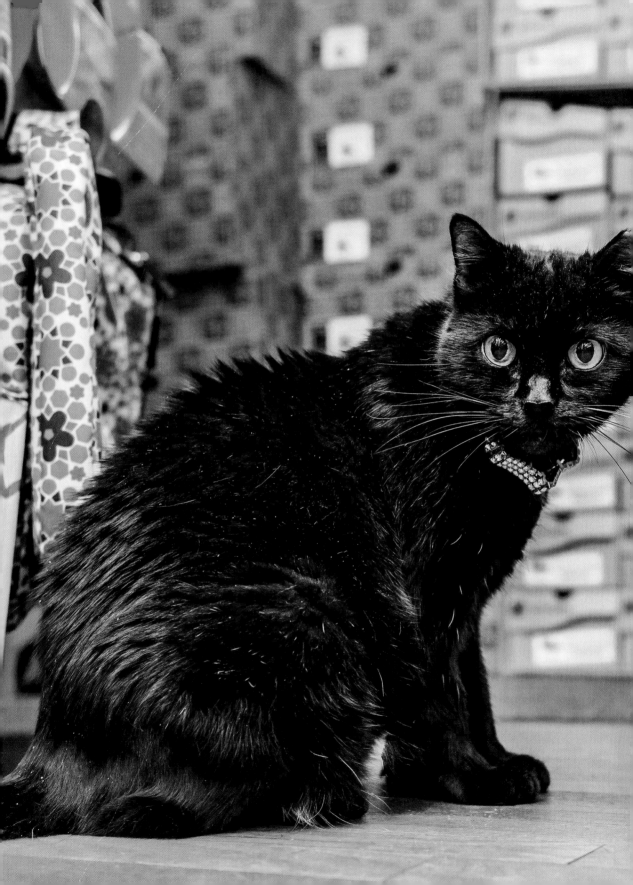

Clive

CANINE STYLES BOUTIQUE
Upper East Side, Manhattan
Dog Boutique and Groomer

When I spotted a large gray tabby sleeping comfortably in the front window under a sign reading "Canine Styles," I had to ask why a dog-only boutique and grooming business would have a resident cat. An employee replied without looking up or cracking a smile, "Well, someone has to keep things in order around here."

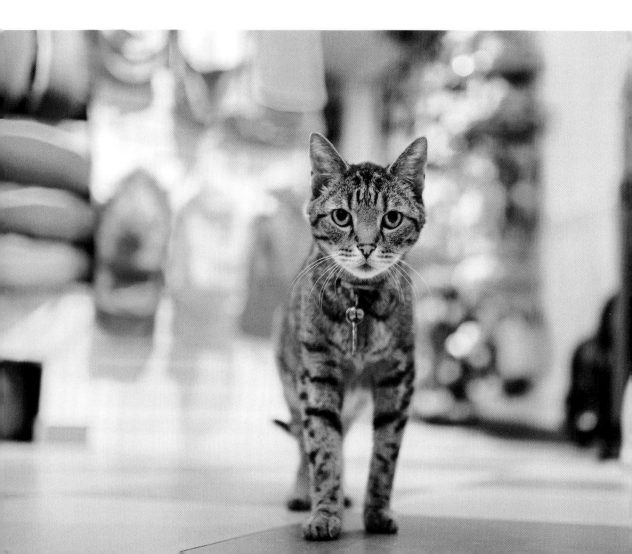

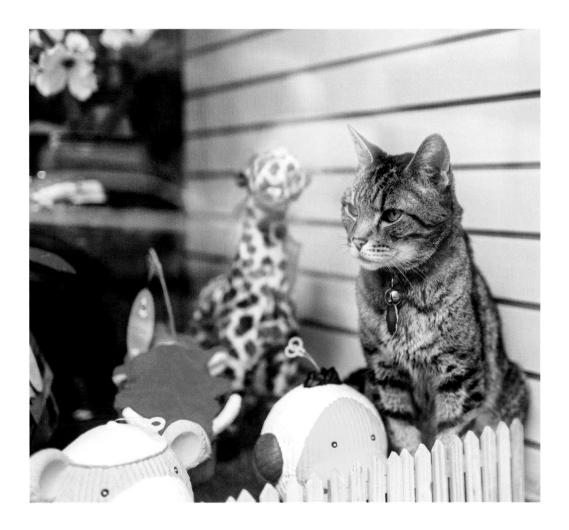

The store's owner, Mark, was a self-professed dog man when he got into the business. He attributes his conversion from dog man to cat lover to Bebe, a feline he inherited with his first boutique. She showed Mark "how affectionate and smart cats could be by her personality and intuition. Bebe sensed which dogs she would get along with, and which to avoid."

Mark shares the East 81st Street store with a twelve-year-old tabby by the name of Clive. An incredibly friendly cat, Mark says he's become quite a neighborhood draw. The younger children come by with their nannies while the older ones drop by in the morning on their way to school to visit him. Some even come back once they've grown up to check in on Clive and see how he's getting along. He even has a doggie fan contingent whose parents share treats they've just purchased with him.

During the winter months, if Clive isn't visible in the window, concerned residents inquire to make sure he's okay. But as many human New Yorkers do, Clive merely relocates to warmer haunts.

When I asked what Mark thought about people not frequenting his business because of his cat, he responded without missing a beat, "My cat comes first. My cat lives here."

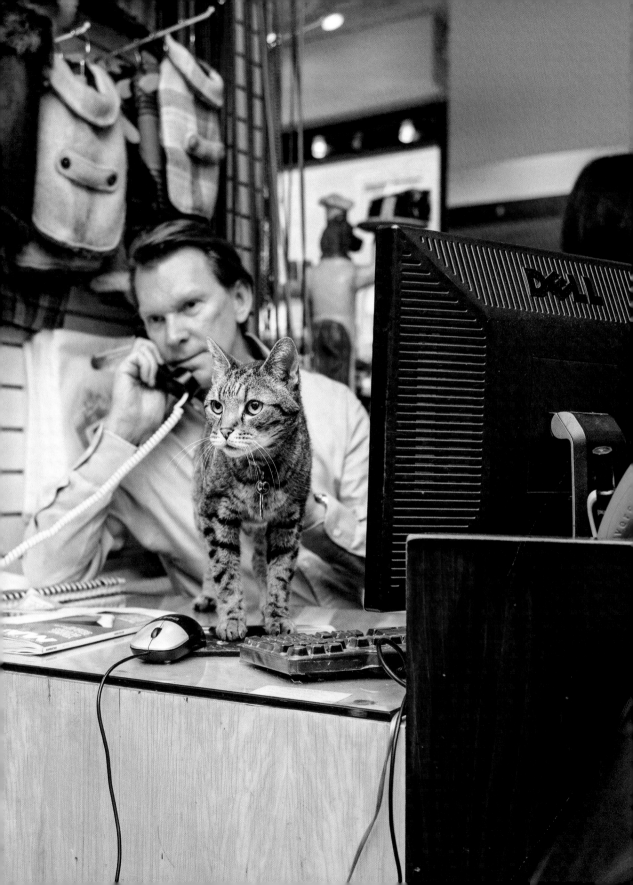

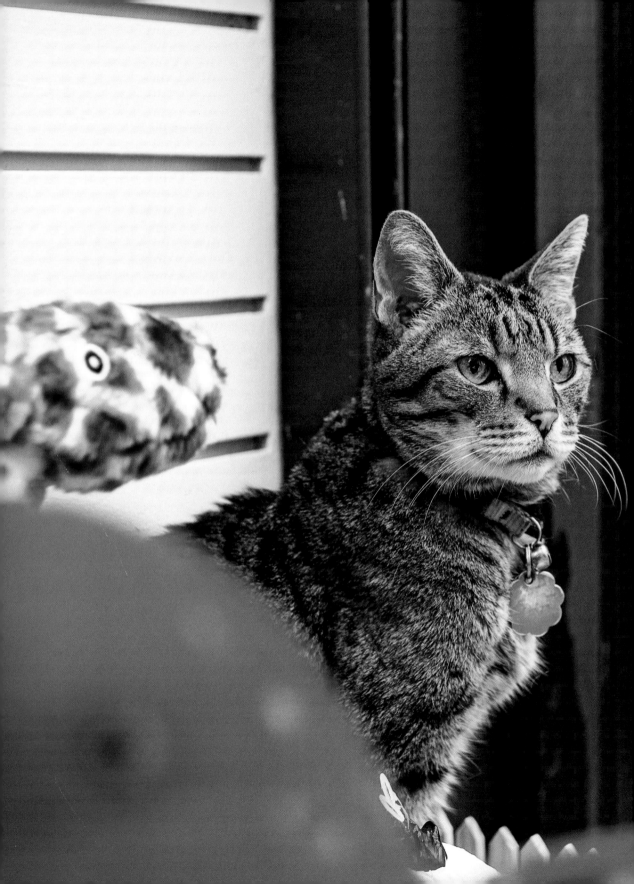

Jeffie

KINGS COUNTY DISTILLERY
Brooklyn Navy Yard
Whiskey Distillery

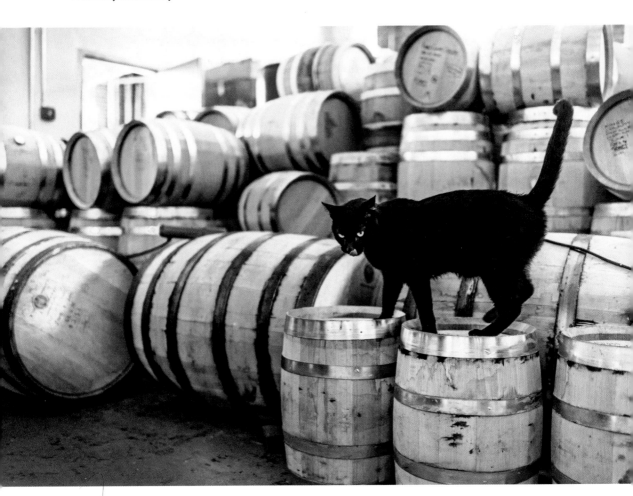

Kings County Distillery is the oldest operating whiskey distillery in New York City since Prohibition. Its ruler, "King Jeffie," as he is fondly called, dons a sleek black coat and has four legs.

Felines and granaries have a relationship dating back thousands of years. Granaries are often credited for the domestication of the cat—that is, if you believe their domestication is even possible.

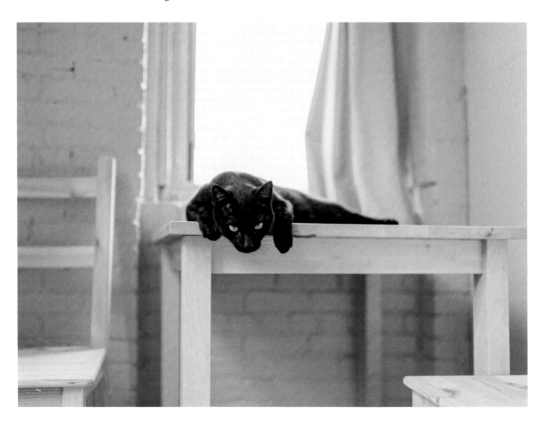

Jeffie rules with a gentle touch. "He catches mice and birds but doesn't kill them," according to Becca, the distillery manager.

When tours come through he can be counted on to head-butt a few attendees in order to get the attention he so desires and deserves as King.

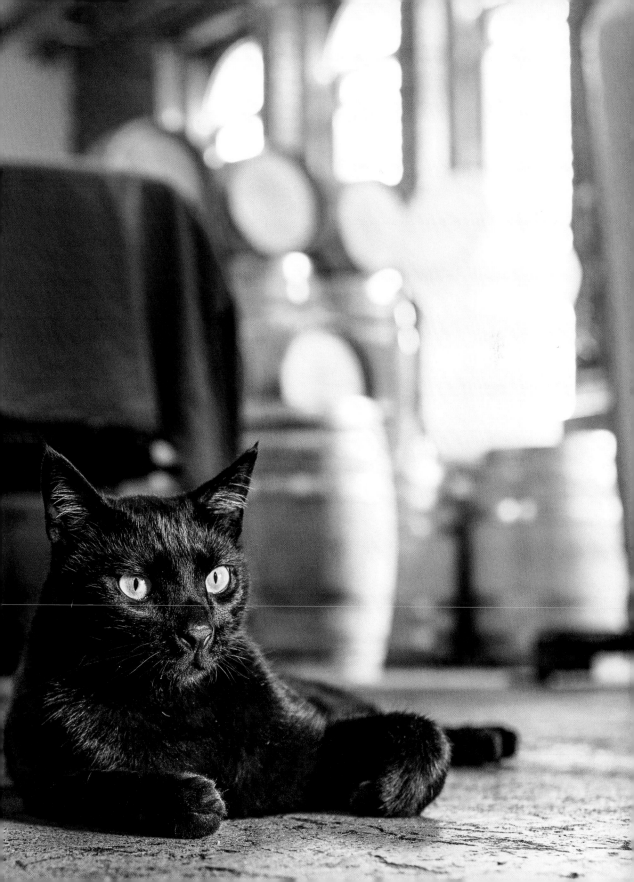

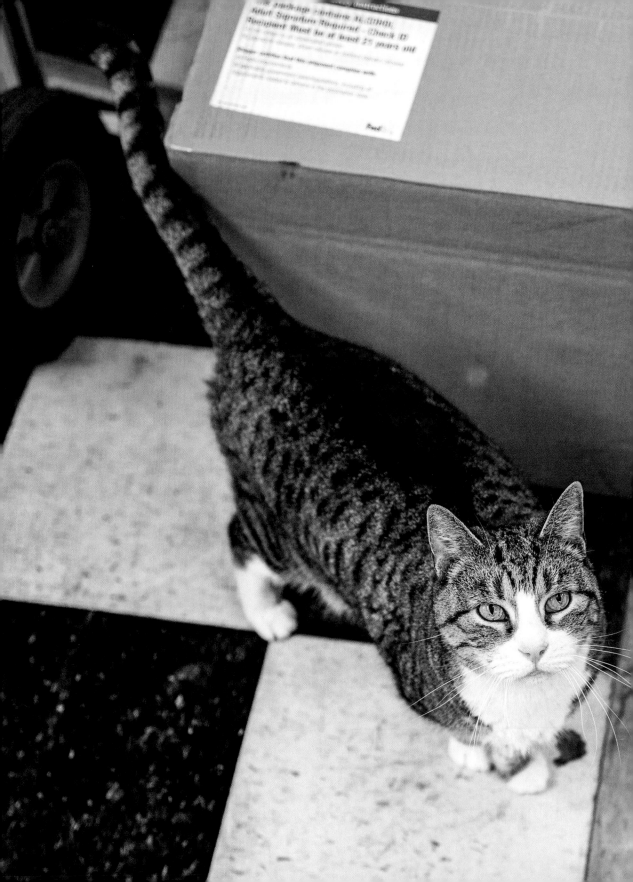

Charlie

PARK SLOPE COPY
Park Slope, Brooklyn
Copy Center

Charlie and his sister Christina found their way to Brooklyn
by way of Long Island. The kittens were fortunate enough to
be at the right place at the right time when the feline-centric
family that owns Park Slope Copy made a pit stop coming
home from a weekend outing.

According to Jamie, the shop's manager, Charlie was always the more svelte and energetic of the two. While he jumped over the counter, his sister, being on the chubbier side, "would do this spread eagle thing to wiggle through the few inches of open door space."

When younger, Charlie, the spry kitten, would make himself comfortable by perching on customers' shoulders. Now fifteen, he continues to be friendly and tolerant of overly zealous children who squeal with happiness upon spotting him.

Sadly, Christina passed away last year, which has been a big adjustment for Charlie.

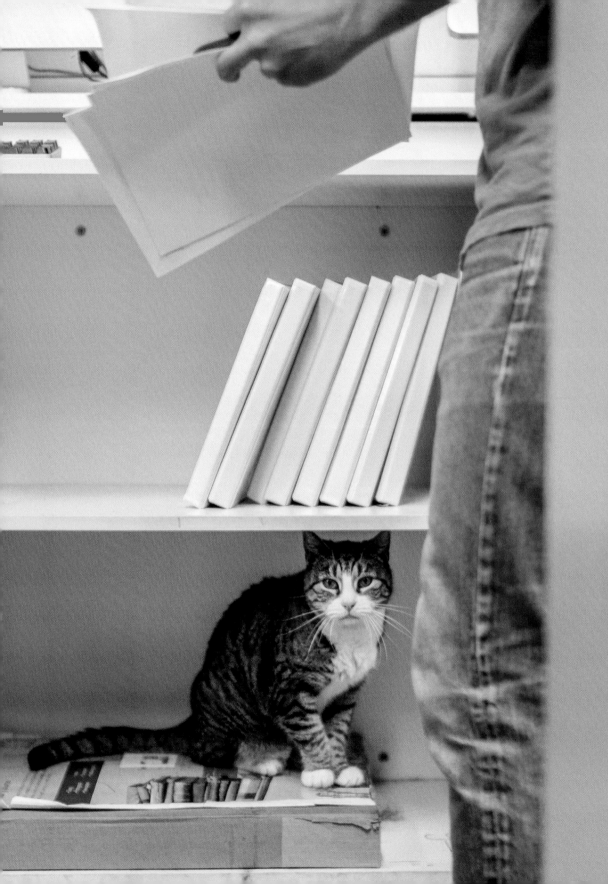

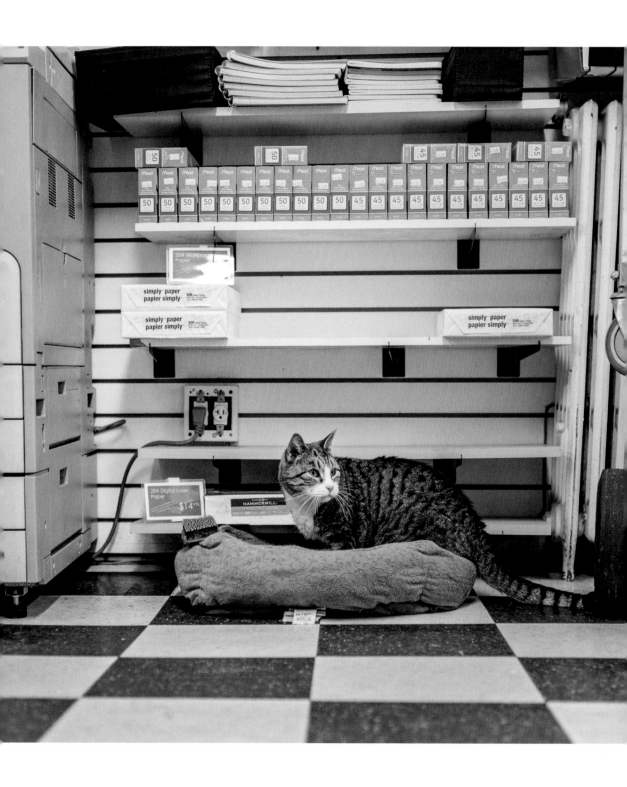

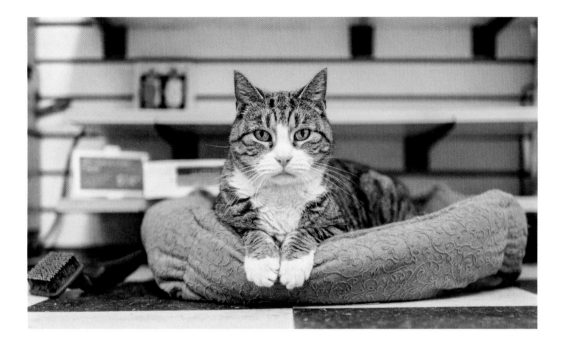

When I asked Jamie how Charlie took his sister's passing, he told me, "One night I was there work-ing late and he started with these meows, they were heart-wrenching cries. I didn't think I could take it for much longer. I had to pick him up and walk around with him for a while. It went on for a few weeks."

Since Christina's passing, Charlie has changed his home base from the copiers, where they shared a bed, to the shelves where reams of paper are stored, perhaps for a fresh start.

While cats at a copy shop may not make much sense at first, Jamie pointed out it's a take on *copy cat*, which was almost the shop's name. Charlie will have the honor of being the shop's last cat when his time comes, as the newer copy machines are more sensitive to foreign objects like dust— and cat hair.

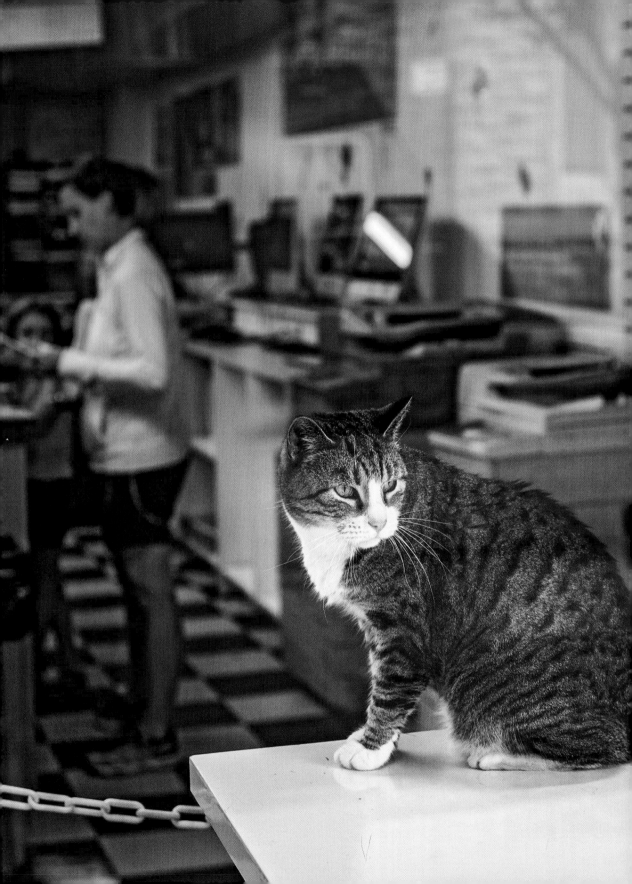

Eros, Medea, and Zero

ENCHANTMENTS
East Village, Manhattan
Occult Store

Enchantments is a tiny East Village shop overflowing with people and cats. The walls are lined floor to ceiling with books, candles in a variety of shapes (from feline to the unmentionable), and jars of various sizes containing mysterious substances like snake root, bluing balls, and chickweed herb.

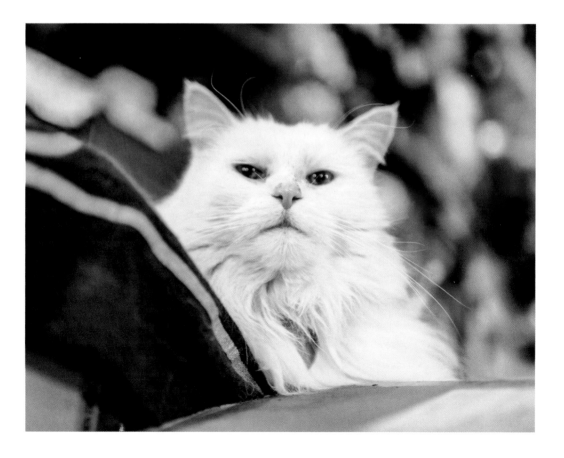

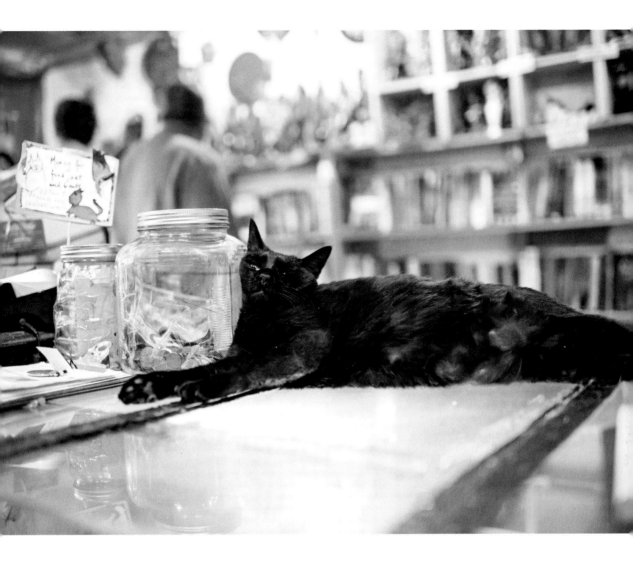

When I asked senior manager Stacy why she has cats, she responded, "Witches and cats." And in accordance to what I imagine the occult handbook dictates, the shop has always had at least one black cat in residence.

Currently the store is home to two black cats, siblings Eros and Medea, who arrived as kittens and have been "squatters for ten years," Stacy says with a chuckle, along with a long-haired white cat named Zero. Medea, Stacy makes a point to clarify, "is named after the first witch in Greek mythology. Not the actor."

Stacy believes the felines bring with them "positive energy and magic." While Eros is "selectively friendly," it's Medea who provides customers who need it with emotional support. Her primary station on the counter-top near the register, situated at the entrance of the shop, makes her easily accessible for petting and scratches behind the ears.

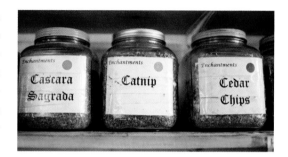

When I ask Stacy what she meant by "magic," she explains, "Some evenings Medea likes to cast spells with something in her mouth; sometimes she grabs a wand and mews at the top of her lungs as she walks around the shop." Asked to speculate on the nature of the spells she casts, Stacy believes they're "probably about being fed or getting catnip."

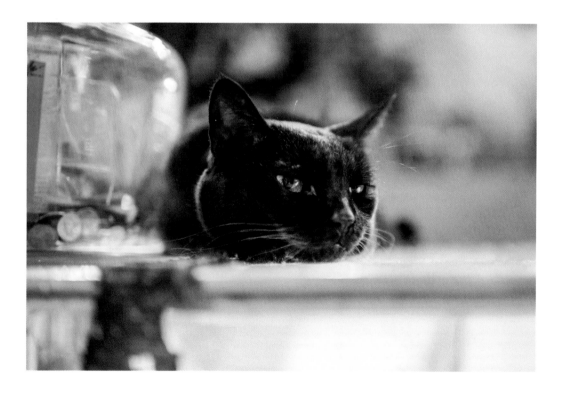

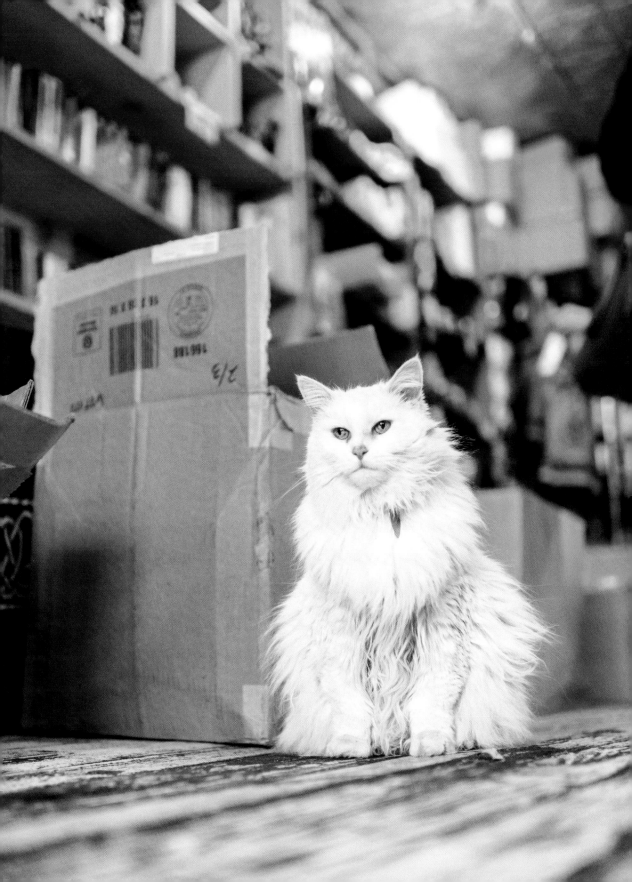

KATE
ATKINSON

A NOVEL

A
GOD
IN
RUINS

BY THE AUTHOR OF LIFE AFTER LIFE

DAVID
McCULLOUGH

THE WRIGHT
BROTHERS

The
Unfortunates

a novel

Sophie McManus

IN GOD
RUINS

BY THE AUTHOR OF LIFE AFTER LIFE

the
Unlikely
Event

A NOVEL

Tiny

COMMUNITY BOOKSTORE
Park Slope, Brooklyn
Bookstore

Originally the runt of a litter, today Tiny lords over the Community Bookstore in Park Slope, having earned the nickname "Tiny the Usurper" (also his Twitter handle).

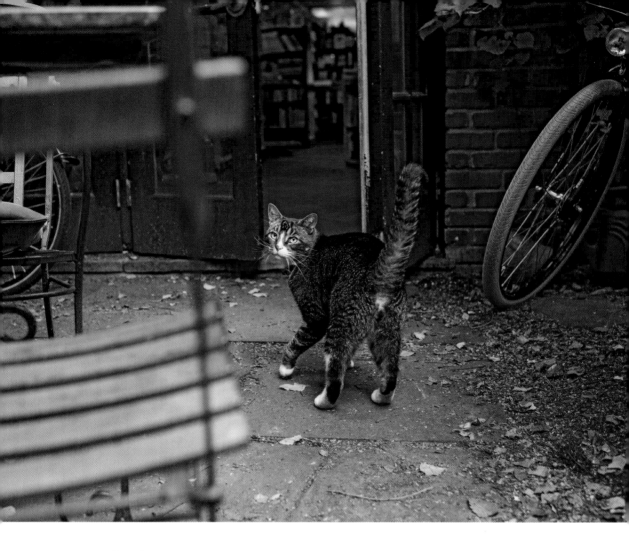

To say he's feisty is an understatement. The bookstore has a lovely back patio with a built-in pond, a veritable ecosystem complete with squirrels and pigeons, both of which Tiny has tangled with and come out none the worse for wear. His stalking abilities were evidenced the day he entered the store with an entire pigeon in his mouth—still alive, wings outspread. Tiny is now six years of age, and one bookstore employee summed it up best by saying, "Tiny lives to fight another day."

Ezra, a longtime bookstore employee, says kids often ask, "Why he can't be more like the copy center cat?" (refer to Charlie at Park Slope Copy pages 52–59) and that every once in a while "an astute child asks why they have such a mean cat." It's not clear there's a good answer. But despite his crotchety ways the staff is very attached to him, attests Lima, another longtime employee.

And while Tiny lets on that he doesn't like people, Ezra reports that whenever they have an event in the patio, "he comes by and plops himself down in the midst of it." Manager Stephanie jumps in with her assessment: "He's a diva; he wants to be admired and adored."

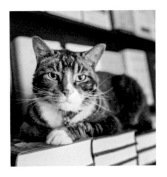

Customers come in with their dogs assuring the staff they're okay with cats, to which the staff responds, "Well, our cat is not okay with dogs. If you see Tiny up in the shelves following you, your dog is being stalked."

Stephanie says that once, during story time with a group of toddlers, "without any warning, the storyteller announced that they had a 'very special guest,' at which point a tall man pulled a chicken out of his overcoat and put it on the ground, wings flapping." Tiny was mere inches away when the chicken was scooped up and a potential slaughter averted.

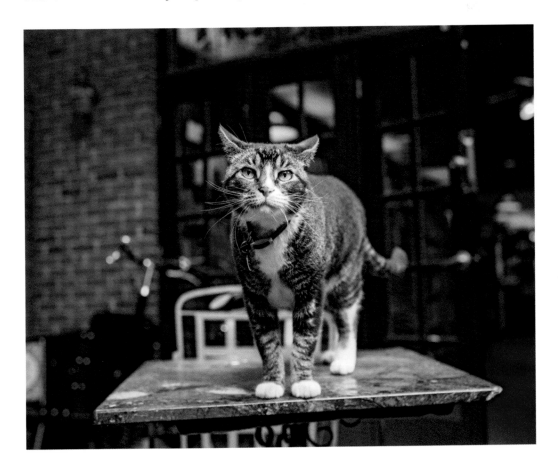

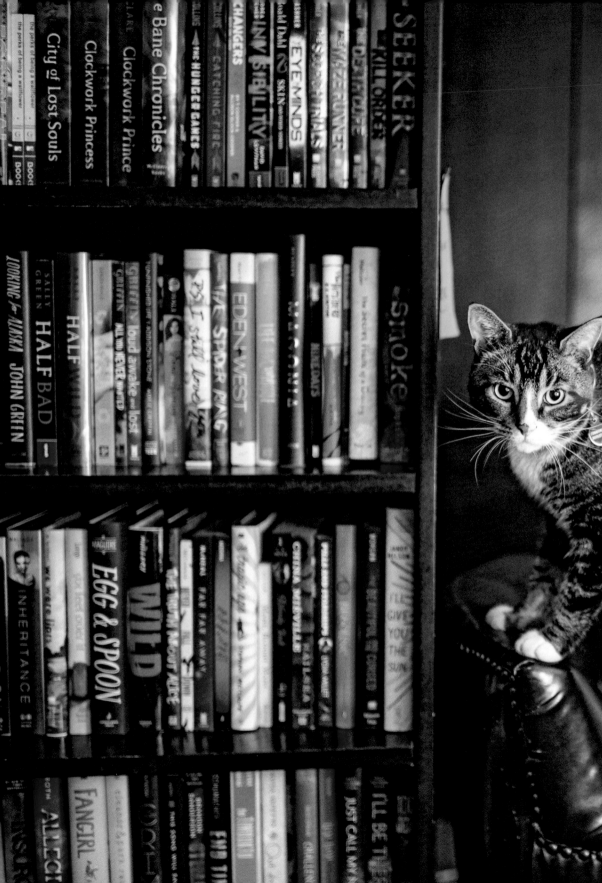

Giovanni Dalle Bande Nere

BROOKLYN GLASS
Gowanus, Brooklyn
Glass-blowing Studio

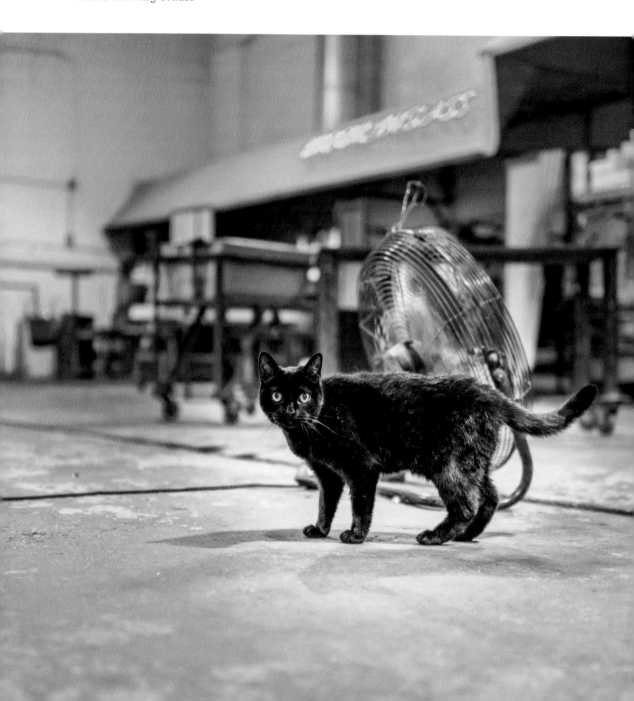

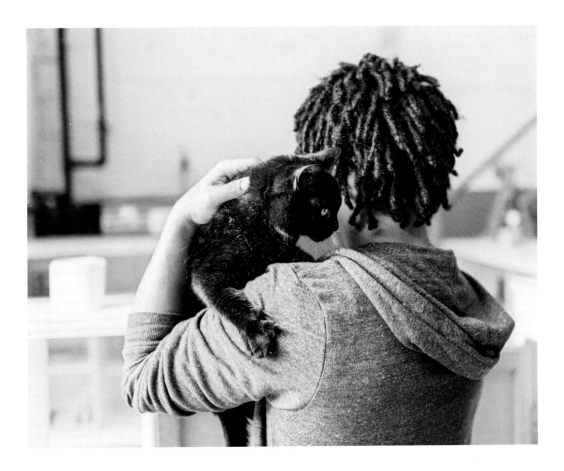

Giovanni Dalle Bande Nere. No, it's not the name of the hottest up-and-coming Italian actress/ model, but rather of a sixteen-year-old cat whose human mom, Cat (short for Catherine), hails from Milan.

Cat says sixteen years ago a black cat, Negrina, came into the shop one day and gave birth to just one little female kitten. Negrina made her home upstairs where the offices are located while the young cat, Giovanni, enjoyed her expansive domain downstairs.

Giovanni kept the glass blowers company, lunching with them and sleeping among their creations in the summer and curling up near the 21,000-degree kilns in the winter; today one of the kilns even possesses her name. As Giovanni grew older and after Negrina passed, Cat decided it was time for Giovanni to relocate to the upstairs area where it was safer for an aging kitty.

"She's still got a lot of feist in her," says Cat. "Perhaps she really is Italian."

Ivy

NEERGAARD PHARMACY
Park Slope, Brooklyn
Drugstore

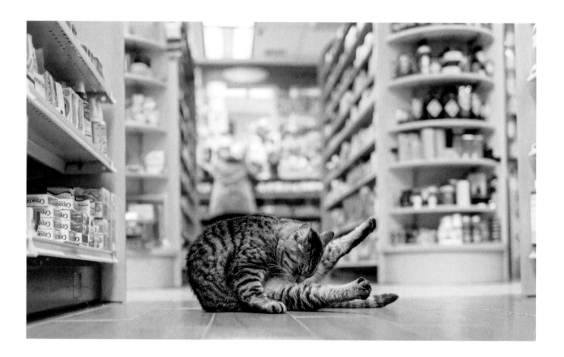

According to Neergaard pharmacist Lana, "Ivy was found as a wee kitten pulling tricks on the gritty streets of Brooklyn's Park Slope." The pharmacy took her in and named her Ivy—not after the plant, but an I.V. It's a fitting name not only because it's a pharmacy but because, as Lana points out, "she got under our skin and into our hearts."

Known among store employees and regulars as "Her Royal Highness Princess Ivy of Neergaard," Ivy rules with "glam flare and steady paw" under the credo "Bring Treats and Thou Shalt Be Spared."

Lana believes the little tabby's predatory roots were finely honed at a young age, allowing her to spot, "the weakest and most gullible human to make her servant number one," though as with all royalty she has a full staff at her beck and call.

Ivy's minions are many and come to see her from far and wide. One woman who has long brought Her Majesty treats and toys moved more than two hours away, but she continues to make regular sojourns to see her ruler—always bearing her credo in mind.

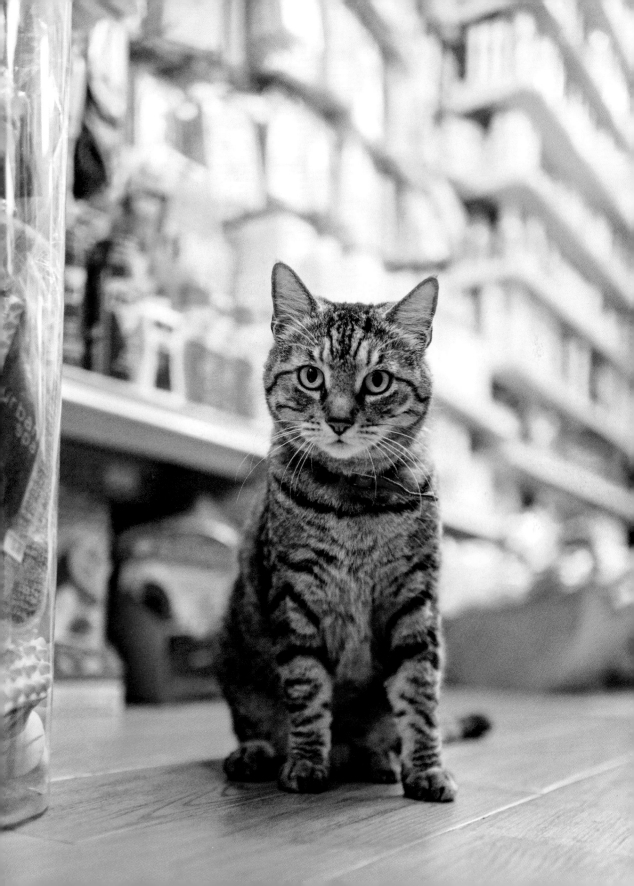

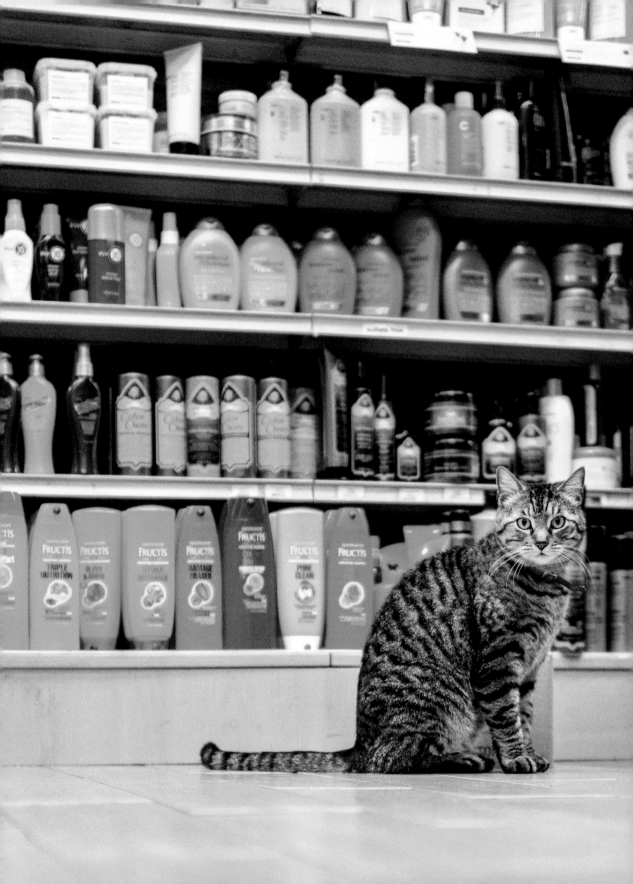

Topeka

MANHATTAN CAT SPECIALIST

Upper West Side, Manhattan
Vet Office

I never realized there were such things as blood donor cats until I met Topeka at Manhattan Cat Specialist. Topeka was found in a feral colony, then spayed and ear-tipped, but once she came out of anesthesia they realized she was anything but wild. According to Dr. Arnold Plotnick, "She loves living in the hospital. She sits in the exam room chair but she knows the rules. If a patient comes in she leaves."

Given her temperament and blood type, she became a blood donor and has saved the lives of at least two cats a year. In 2012, the vet's office announced on their blog that after "six years of valiant service . . . Topeka, has donated her last unit of blood." However, should Dr. Plotnick ever need to demonstrate how to give subcutaneous fluids or injections, or even how to pill a cat, Topeka is always a willing volunteer.

The vet didn't go to school intending to open a feline-only veterinary clinic, but he found feline cases interesting, so they kept coming to him. He admits he'll go into a store even if he doesn't like it if they have a cat—a sentiment shared with many we spoke to during the creation of this book.

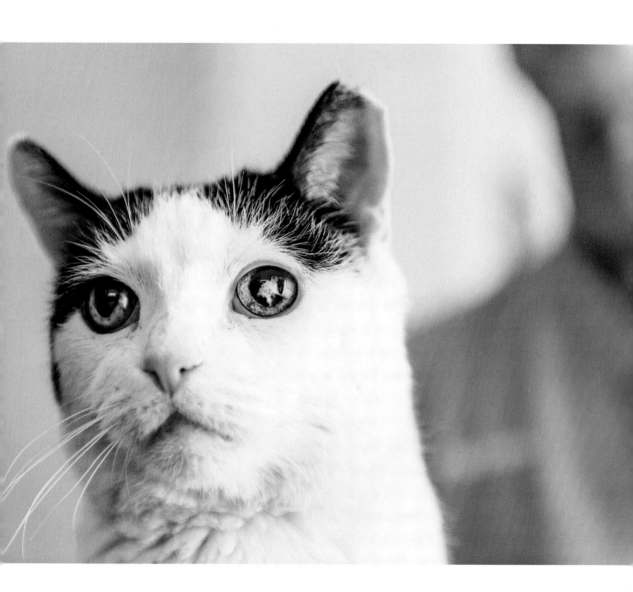

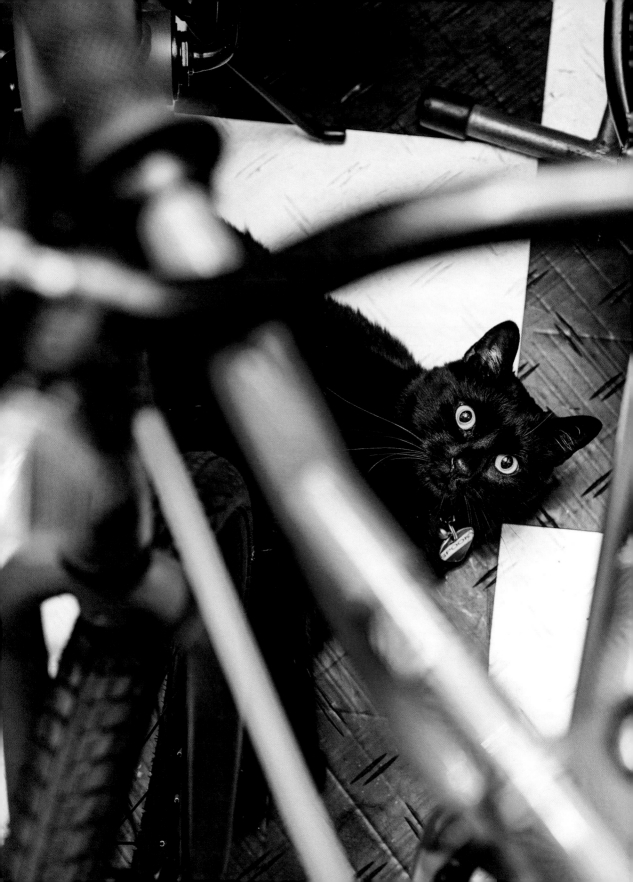

Spooky

ON THE MOVE

Park Slope, Brooklyn
Bike Shop

Spooky does not deserve the baggage that accompanies his name. There's no denying the color of his coat, but beyond that he's not the least bit scary. Quite the opposite. CP, the shop's owner and Spooky's dad, says kids in the neighborhood visit him even in the winter, a distinctly less popular bike-riding season. Upon seeing them, Spooky runs to the front of the shop to greet them and bask in their attention.

Once when a cat-phobic potential bike renter did stop by the shop, CP set her straight, but without losing the sale. He told her, "This is his house. You stay outside, and I'll take care of you out there."

Spooky was found as a kitten on a construction site in Queens, leaving teeny paw prints in wet cement. CP's wife sent him to fetch the kitty. With two cats, Bebop and Hip Hop, at home, CP thought his new friend would make for a good addition to the store. Spooky used to have free range of the neighborhood, going outside as he pleased until, CP confessions tenderly, "I started feeling him." He'd wait for the feline's return at night, often not until 11 p.m., to make sure he was inside safe and sound for the evening.

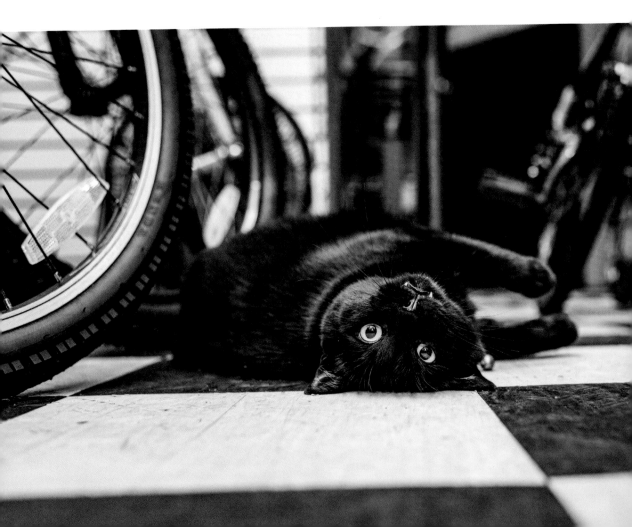

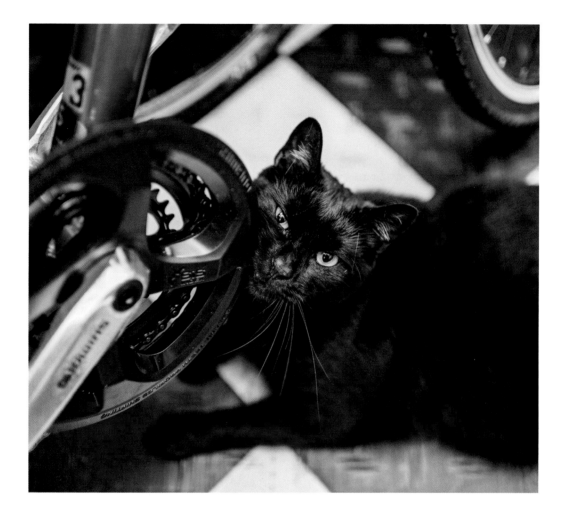

Spooky navigates the narrow shop with aplomb as bikes, customers, and deliveries come and go throughout the day. He's never in the way, and always has one eye on the door to make sure he's not missing out on any action or opportunities for affection.

"He just calms everyone down," says CP. "People are all stressed out in this city; they'll be waiting for a tire change and he'll rub up against them wanting to be petted."

Even the UPS man is smitten by Spooky, spontaneously professing his love for him upon hearing he was the topic of our conversation. Spooky's love does not discriminate. "He even kissed a big dog once," CP proudly proclaims.

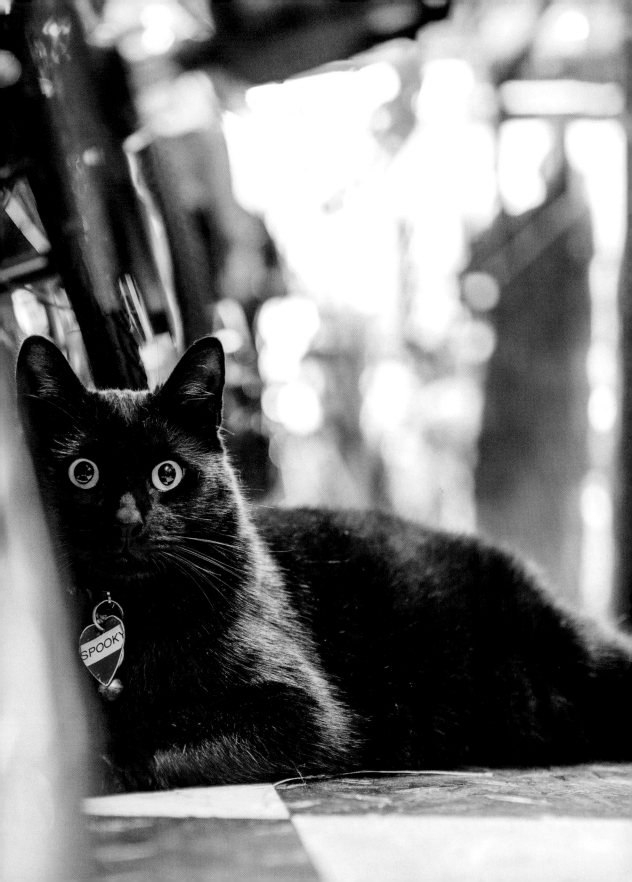

Foster Kittens

PS9 PETS
Williamsburg, Brooklyn
Pet Supply Store

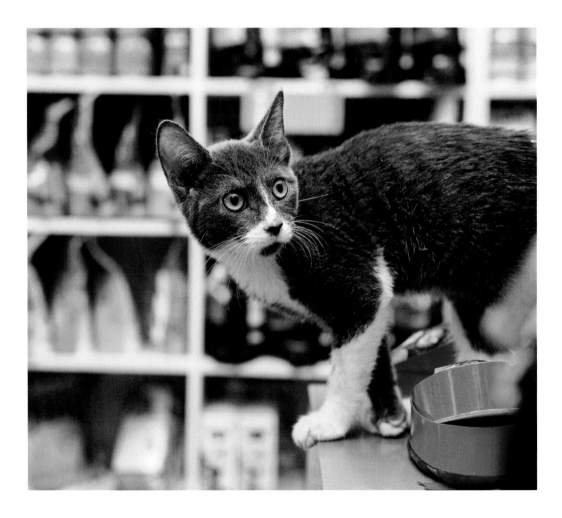

The majority of the kittens fostered at PS9 Pets come from the New York City kill shelter. Being fostered at the pet store is potentially their only opportunity to make it to adulthood. When I asked Joan Christian, the owner, how many kittens have passed through her doors during the six years she's been fostering she replied, "I'd love to know. Hundreds!"

While she's come close, Joan hasn't had her heart stolen by any of the fosters yet, though she believes one of her coworkers has taken home at least three "foster fails."

At one point during our visit she looked quizzically at the towering cat cage and did a quick head count. It seemed there was an extra kitten who hadn't been there the day before. An employee later confirmed her suspicions that another kitten had been dropped off in her absence. It's no wonder she can't keep track!

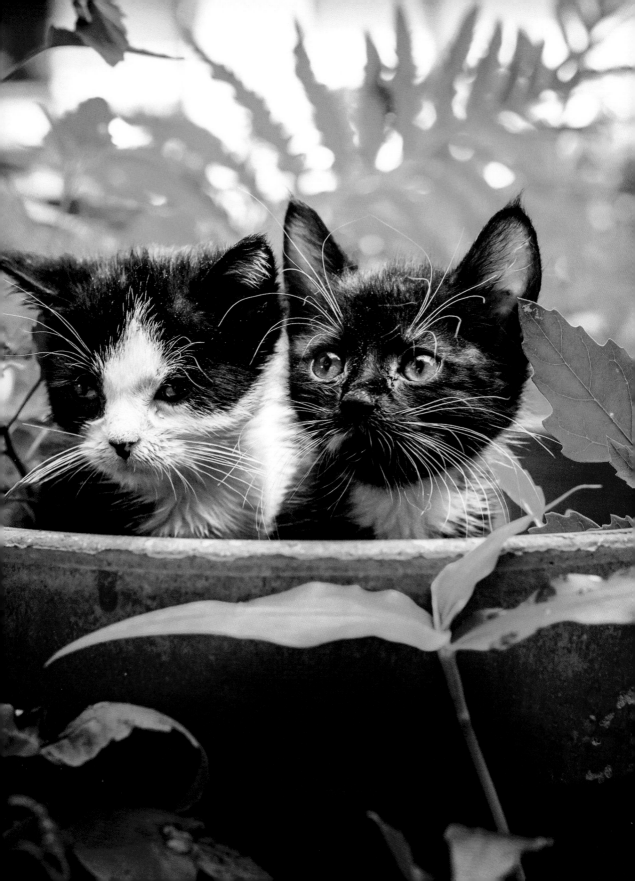

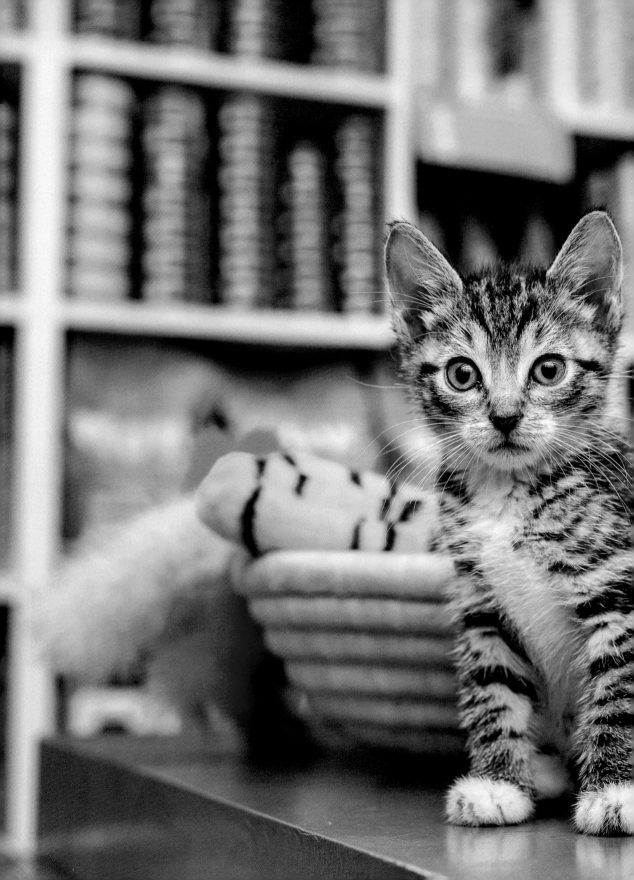

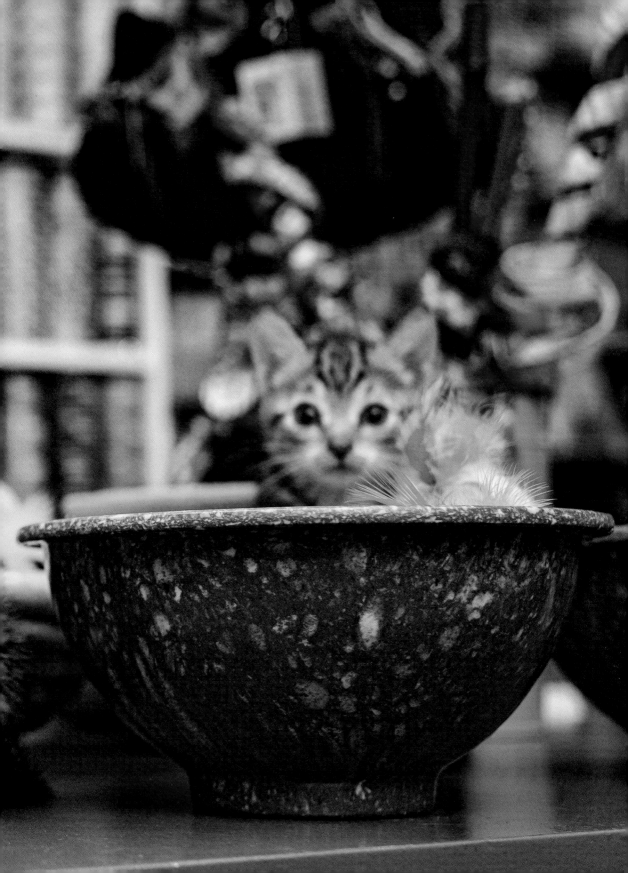

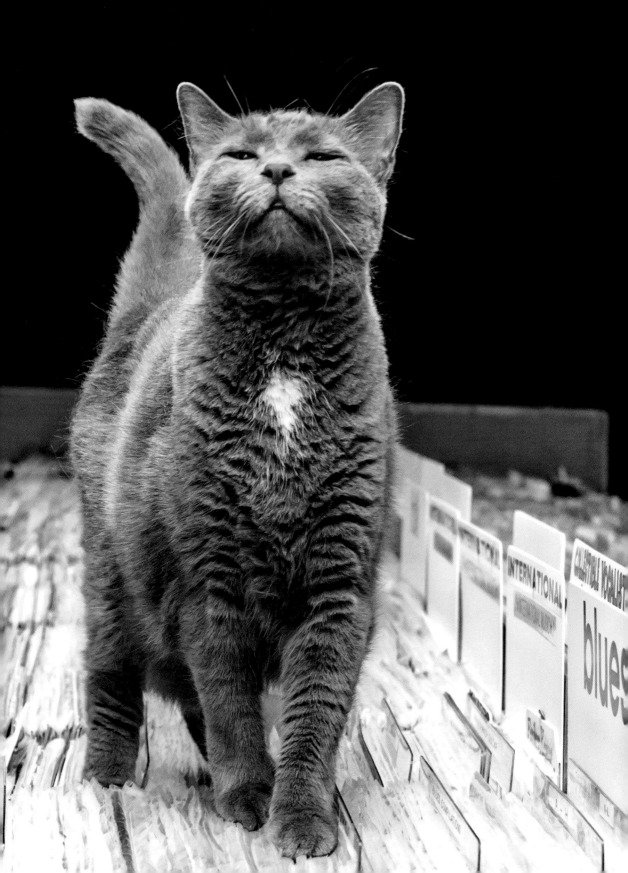

Keetah

BLEECKER STREET RECORDS
West Village, Manhattan
Record Store

There are those who come to Bleecker Street Records, one of
the last old-school record stores in New York City, not to coo
over the impressive vinyl collection but to visit a gray cat
with a white heart-shaped patch on her chest.

Keetah is the record store's mascot; her likeness is emblazoned on T-shirts and buttons that are snapped up by tourists the world over, making her quite the international star.

When asked why he got Keetah and her now deceased brother, general manager Peter refers to a vague "mission of mercy." They were already shop cats elsewhere but, for whatever undisclosed reasons, could no longer stay where they were.

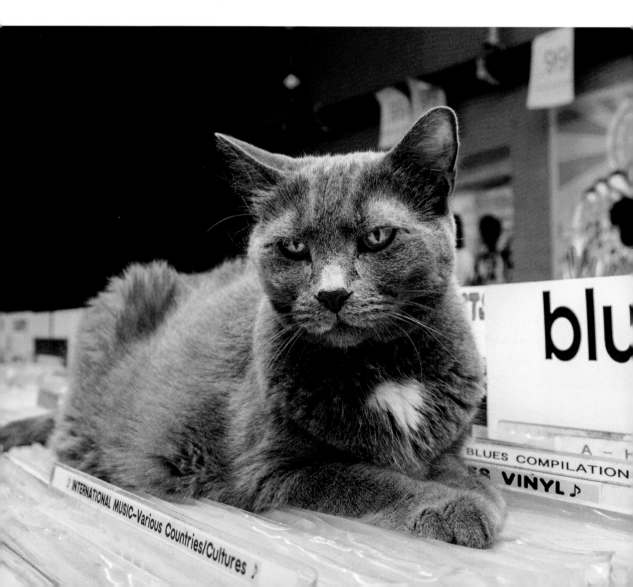

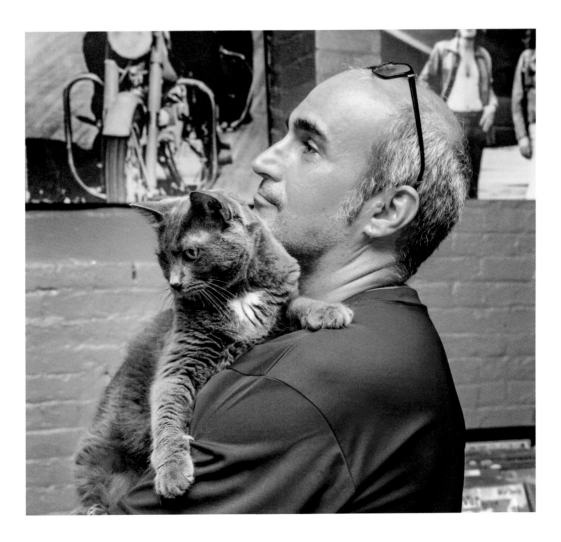

While not being fawned over by fans—"You can set your clock by them," says Peter, Keetah's number one fan—Keetah enjoys the relative solitude of her basement lair where she retreats for peace and quiet among the vintage vinyl.

Valentina

REMINISCENCE
Flatiron, Manhattan
Gift and Vintage Store

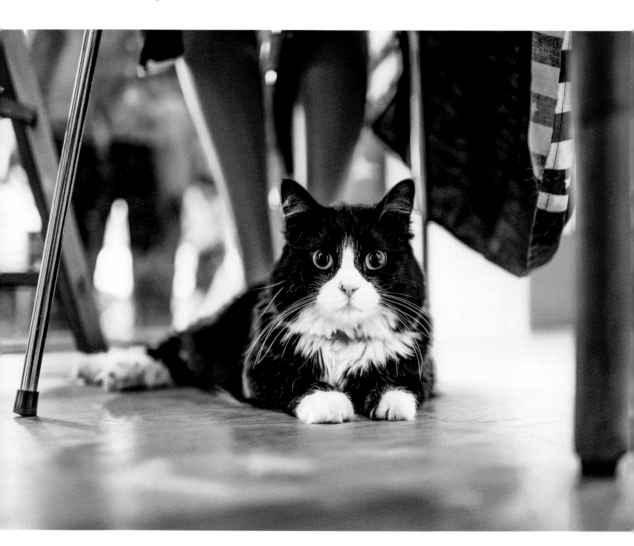

Valentina is named after Valentino, the nearby deli where she lived in the basement until Joan, the manager at Reminiscence, liberated her years ago. As she puts it, Valentina "went from a bodega basement to a fabulous Fifth Avenue condo." Well, a cat condo.

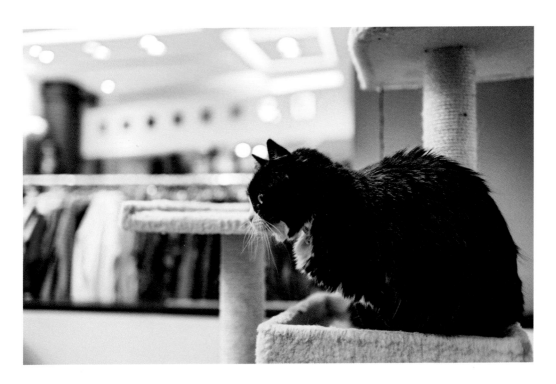

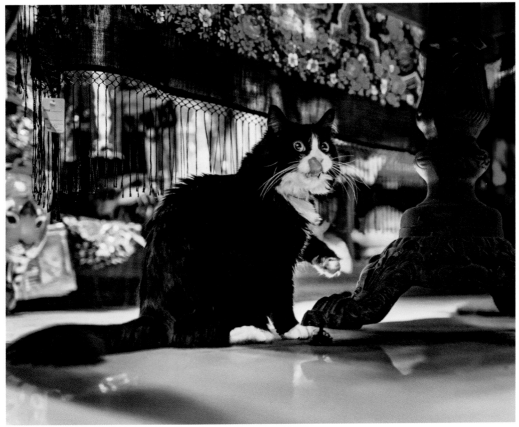

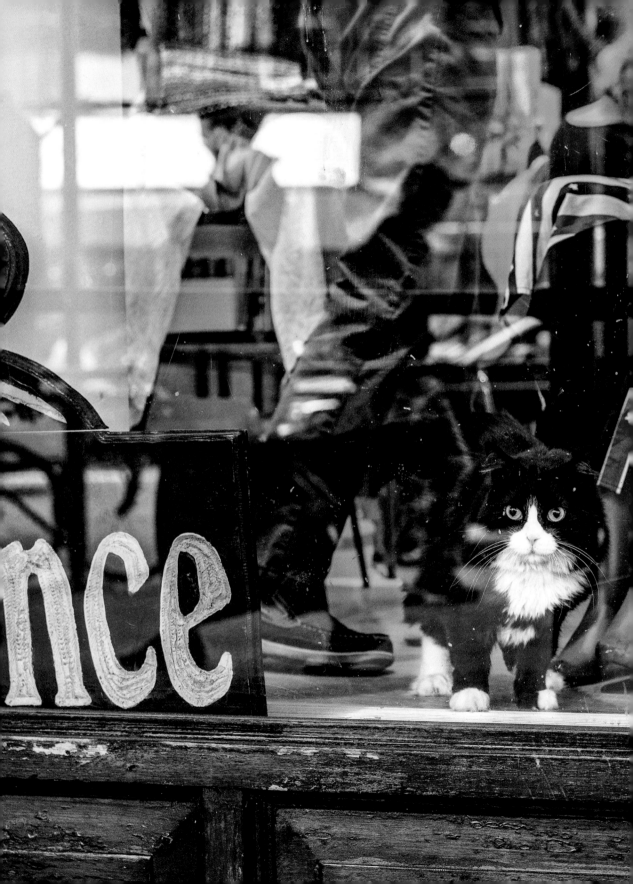

Jasper

FLICKINGER GLASS
Red Hook, Brooklyn
Glass Bending

Jasper arrived at the twenty-two-year-old studio about six years ago when he was one. Now seven, he's smitten his fair share of customers.

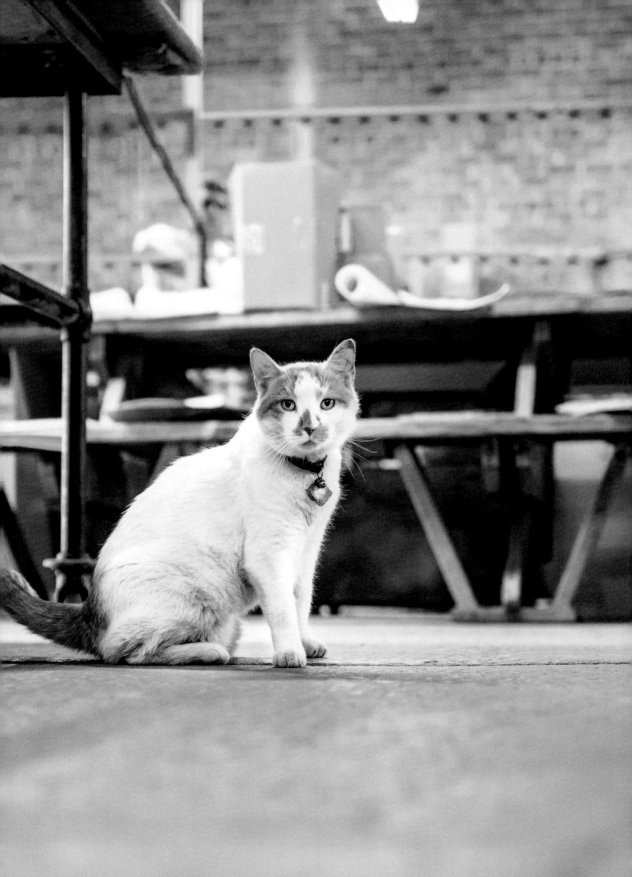

On the day of our shoot Jasper had returned from a visit to a vet at a prestigious Manhattan animal hospital. It seems one of the employees, not satisfied with the level of care he was receiving at a local vet, insisted upon having Jasper's owner make the trek into Manhattan.

Jasper is considered a star attraction in the area and can be quite the charmer. During discussions about custom work that take place in the office, Jasper has been known to sit on a prospective customer's lap—a bold negotiating technique we imagine only a cat could get away with.

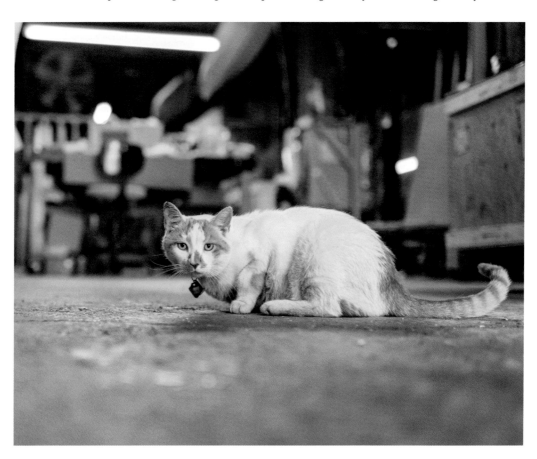

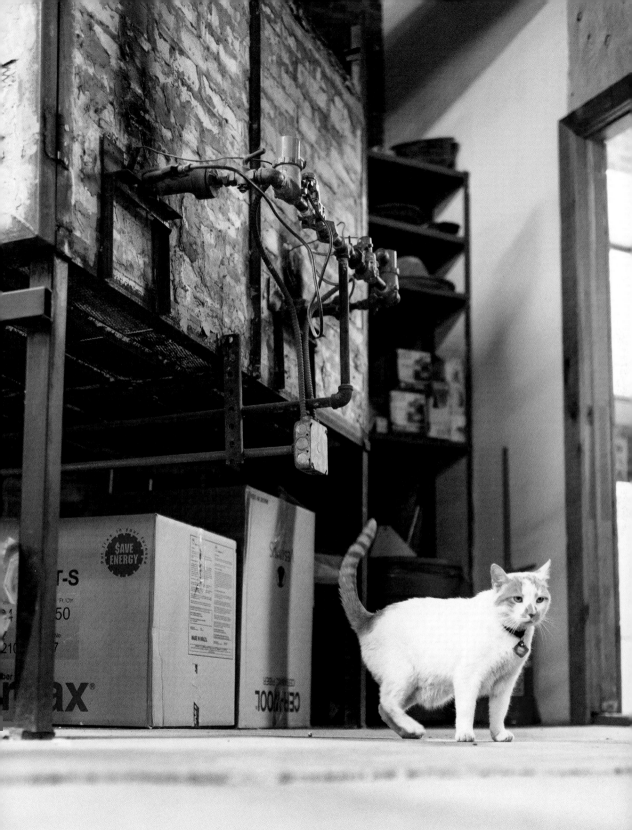

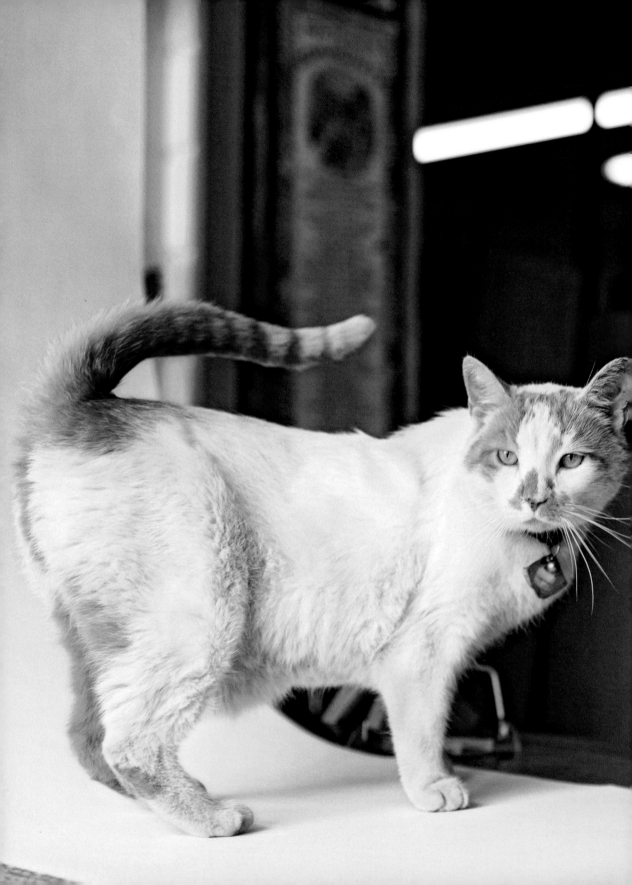

Hampton

CORNER BOOKSTORE
Upper East Side, Manhattan
Bookstore

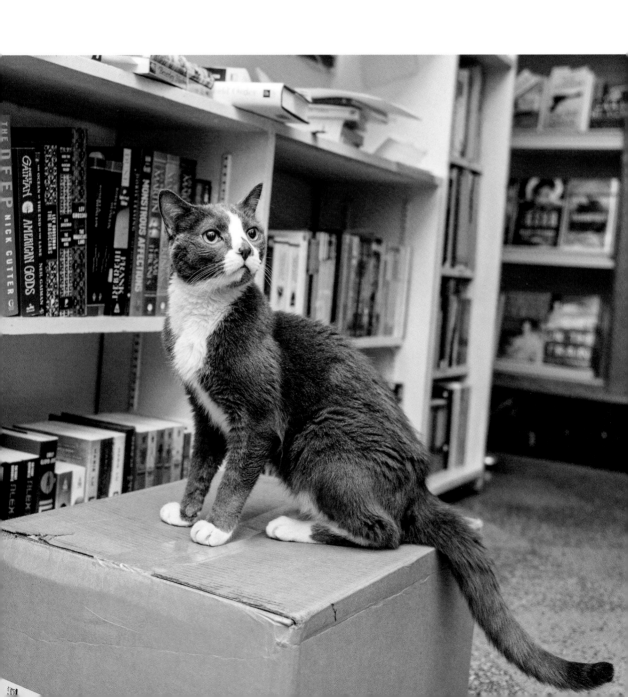

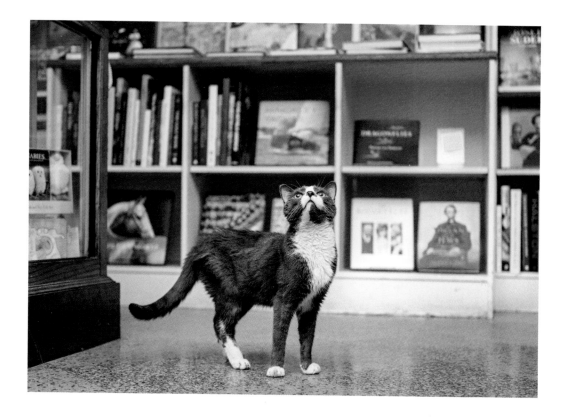

The vintage register and wooden filing cabinets give clues to the location's former life as a pharmacy far before Hampton the cat came to call the bookstore home. He received the name as a remembrance of the tony Long Island area in which he was found before being brought to yet another upscale neighborhood, this time in Manhattan.

Though he's most often hiding out of sight in the basement, he's by no means an unhappy cat. The shipping center is in the basement, where he has access to a never-ending supply of boxes. The Hamptons it's not, but one might imagine it's pretty close to a veritable kitty Shangri-La.

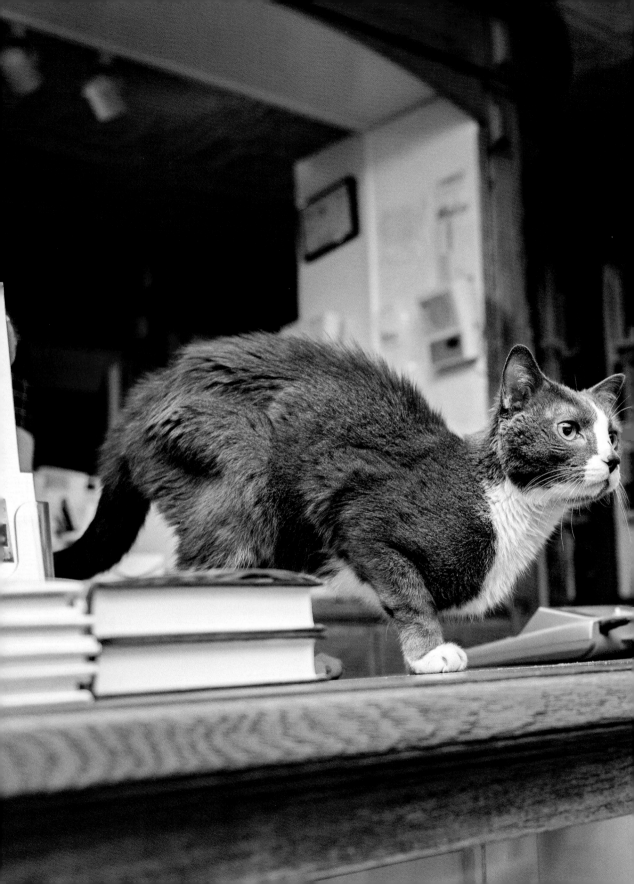

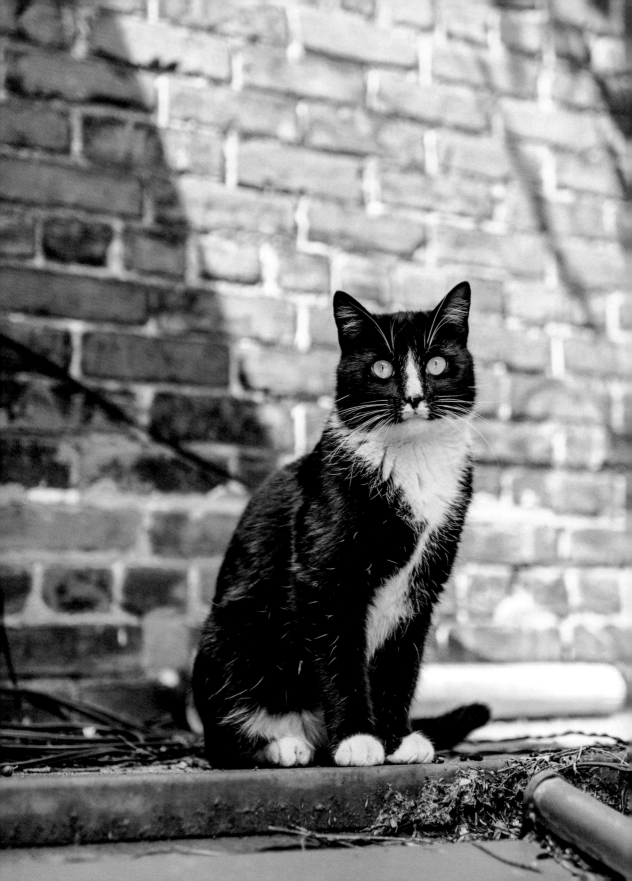

Campus Cats

PRATT UNIVERSITY
Clinton Hill, Brooklyn
University

"It all started when I began feeding a stray," explained
Conrad Wilson, the chief engineer at Pratt University.

Living on campus has its benefits—for the cats at least, who
always know where they can find someone to pet them or
give them vittles. For the most part, however, they come to
eat in the Engine Room, a grand room of antique machinery
dating back to the 1900s, where Conrad's office is located.

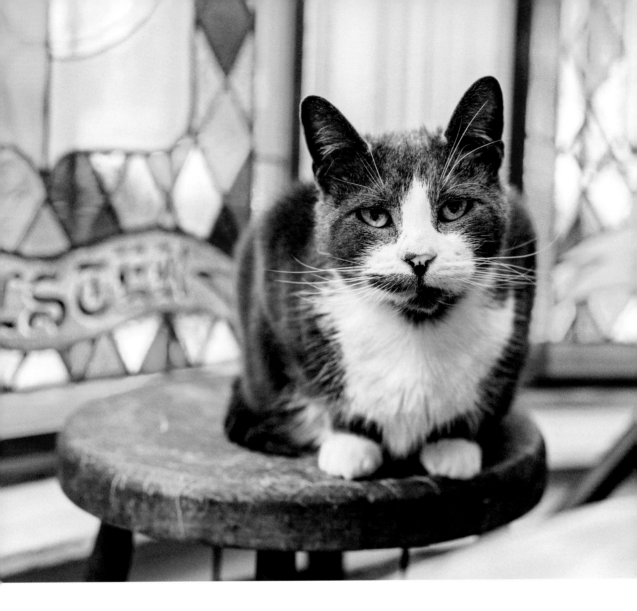

Conrad reeled off the names of the several dozen cats who visit the campus daily but never graduate—"Willy, Prancy, Frenchie, Little Mama, Higgie, Lestat . . ."—all with specific habits, favorite sunning spots, and stories.

One cat in particular, Lestat, loved his fellow college-mates so much he would sneak into the dorms and onto the elevator each evening, getting off on a floor and walking around until a tenderhearted student took him in for the night. When Lestat passed away, Conrad left a note for the students. He was touched to see a large banner erected the very next day with the question, "What Do You Miss About Lestat?" posed on it so they might share stories and grieve as a community.

Conrad arrived at Pratt in 1958 with his wife, who has since passed; together they took care of generations of campus cats, trapping them, taking them to the vet, and getting them adopted when possible. When asked how many cats he suspects he's trapped, Conrad's only frame of reference is a log he found that his wife had kept dating back to 1970 in which she listed over one hundred cats vetted and adopted.

In general, Pratt has been a cat-friendly campus. However, there have been a few incidents, most notably several years ago when the administration decided the cats "had to go." As Conrad tells it, on a Tuesday one of the students started an online petition to save the cats, and by Thursday it had well over a thousand signatures.

Word had gotten out and everyone from the president on down was receiving e-mails and calls demanding the cats stay put. One alum said that if the cats went, he would never donate money to the university again. A student whose entire four years of art had been recently lost in a studio fire wrote that the cats were the only thing that had provided him with solace during a very trying time.

Needless to say, the cats stayed.

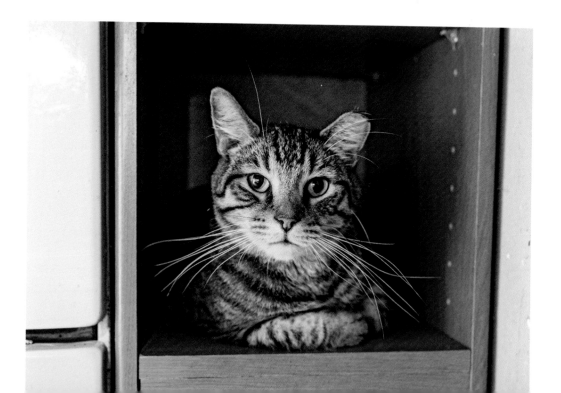

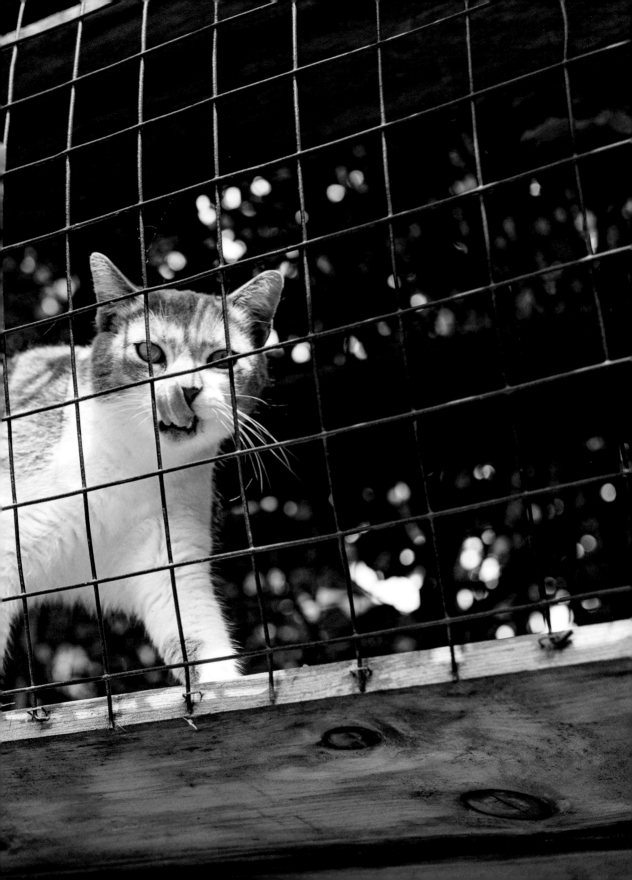

Max

PETS ON THE RUN
Astoria, Queens
Pet Supply Store

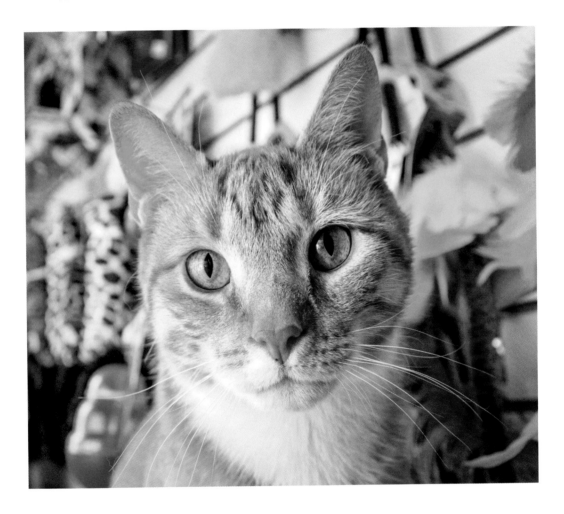

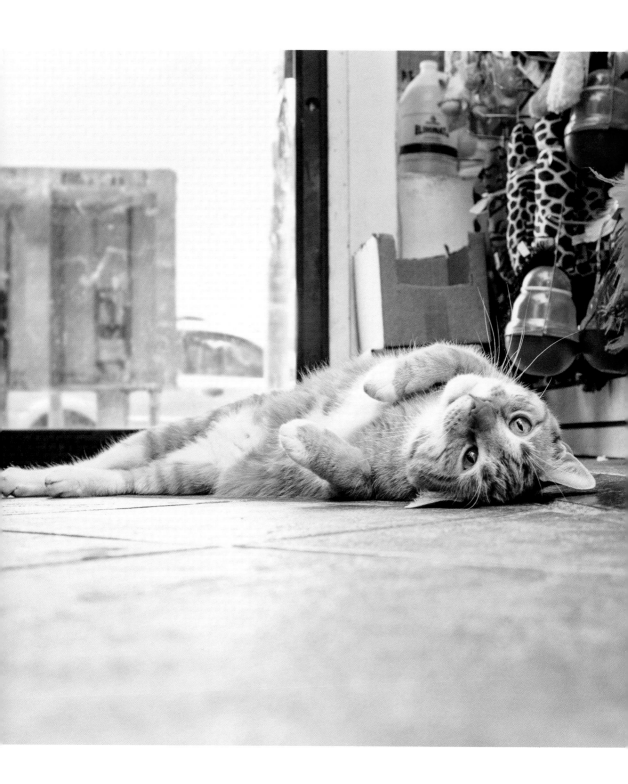

Valentino

CARROLL GARDENS REALTY COMPANY
Carroll Gardens, Brooklyn
Real Estate Office

It was a snowy Valentine's Day in Bensonhurst when, on the way to the gym, Steve Mayo happened across a tiny kitten. Just as Steve spotted him, a woman opened her window and yelled at him to please take the poor thing, as he'd been out there alone for days.

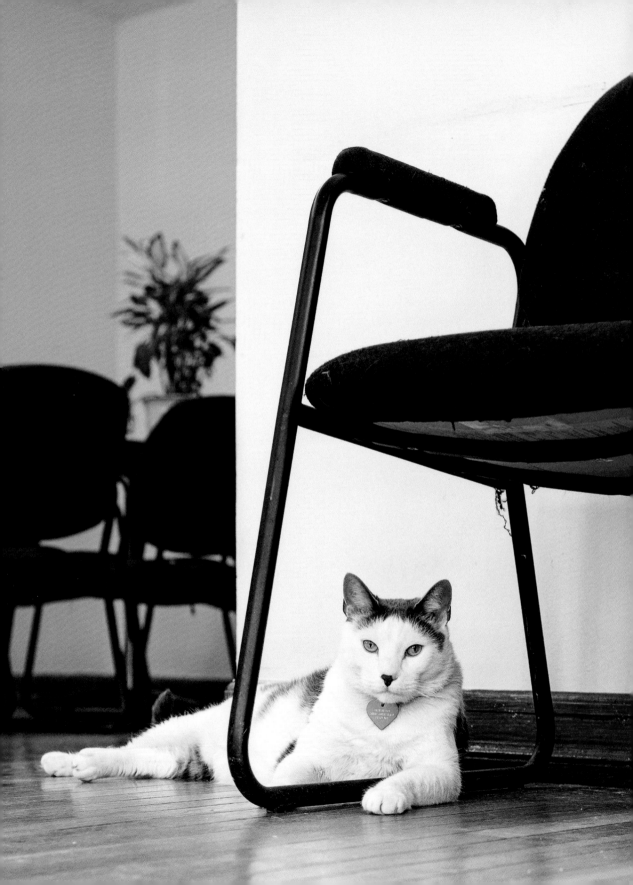

Knowing his dad to be a big animal lover, Steve complied. They put fliers up but no one responded so they decided to keep the little guy in their office at the real estate company owned by Mike, Steve's dad.

Nine years later it's hard to imagine the same cat, with his heart-shaped nametag, as being compared to anything smaller than a toaster. But he's the light of Mike's eyes and it's obvious his love is reciprocated. Mike demonstrates how he's taught Valentino to "do paw" for treats, and proudly tells us about the children who draw pictures and write letters to him in crayon (each letter or picture being prominently displayed in the window, along with the apartment listings).

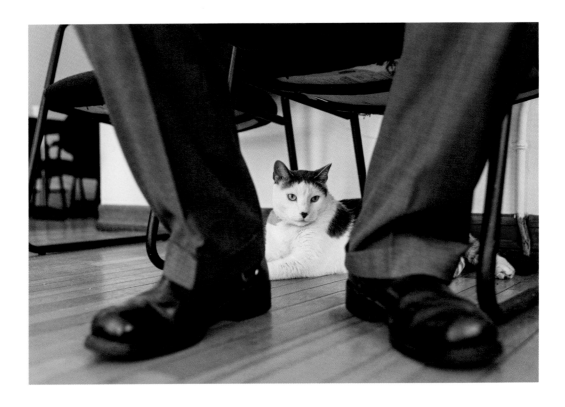

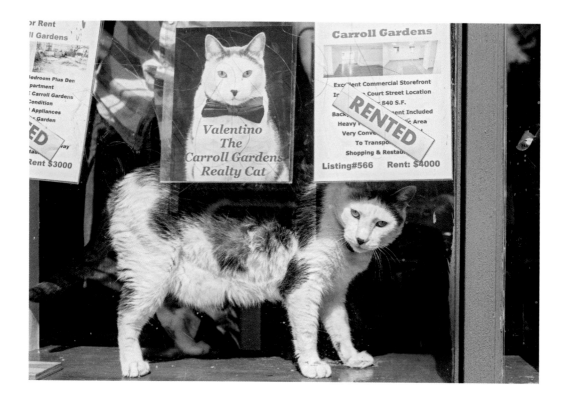

Valentino has no shortage of fans. According to Mike, a group of at least fifty people drop in to say hi and check on him each week. Some knock on the glass or even "pet" him through the window that has a sign in it bearing his image; Valentino rubs up against the visible hand in response. "Some folks come right at closing time, so I have to open up and let them back in," he says.

Valentino gives the office "a warm feeling": "It's almost like a home because he's here. He greets us at the door and talks to us in the morning," Mike says. When I ask if he thinks it reflects on the business, he responds without missing a beat. "Positively, it shows that we are loving people, we have big hearts."

"On his birthday we have a small cake and some coffee, whoever is around participates," he says. And of course, they celebrate his birthday on Valentine's Day.

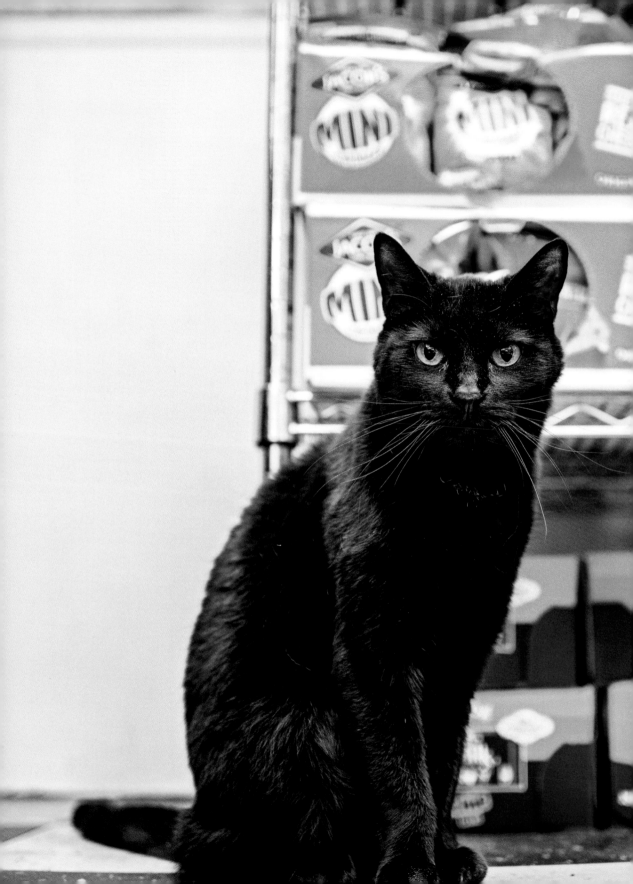

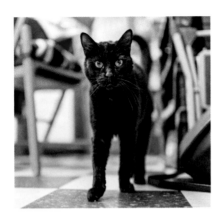

Molly

MYERS OF KESWICK

West Village, Manhattan
British Grocer

Mr. Peter Myers, the owner of Myers of Keswick, felt something was awry the first night his cat Molly missed her 7 p.m. dinner feeding. His mind immediately went to a kidnapping (or in this case, a cat-napping). And while he was sad at the possibility, "My only thought was that I hope she'd gone to a good home," he recounts.

The next morning when he opened the shutters at nine, Molly's daily cue that breakfast was on its way, he heard her meows coming from somewhere in the shop. Kevin, an affable construction worker who happened to be doing work in the area, volunteered to help locate the cat in exchange for a few beers. Whenever they thought they'd located her, they chiseled, hammered, and dug but came up empty-handed. Mr. Myers had many sleepless nights as the shop and basement began to resemble Swiss cheese. Yet the meows persisted.

This went on for weeks. Molly's plight made the evening news, the *New York Times*, and *Regis and Kelly*. Satellite trucks lined the streets, and the *New York Post* had someone dressed in a mouse costume stand outside the shop every day from nine to five, awaiting Molly's emergence. One afternoon a gentleman who happened to be walking past asked what all the hubbub was about. He said, seeming overly assured, "I can find her." He went to his apartment and returned "with some sort of equipment," recalls Mr. Myers. It turns out the gentleman was a professional sound technician. He dropped a microphone into the wall and quickly pinpointed Molly's whereabouts.

She had been stuck in a drainpipe between Myers of Keswick and the neighboring establishment. When she was finally released, Mr. Myers treated her to a special meal of sardines in olive oil imported from England, "at which she promptly turned up her nose," he says, chuckling.

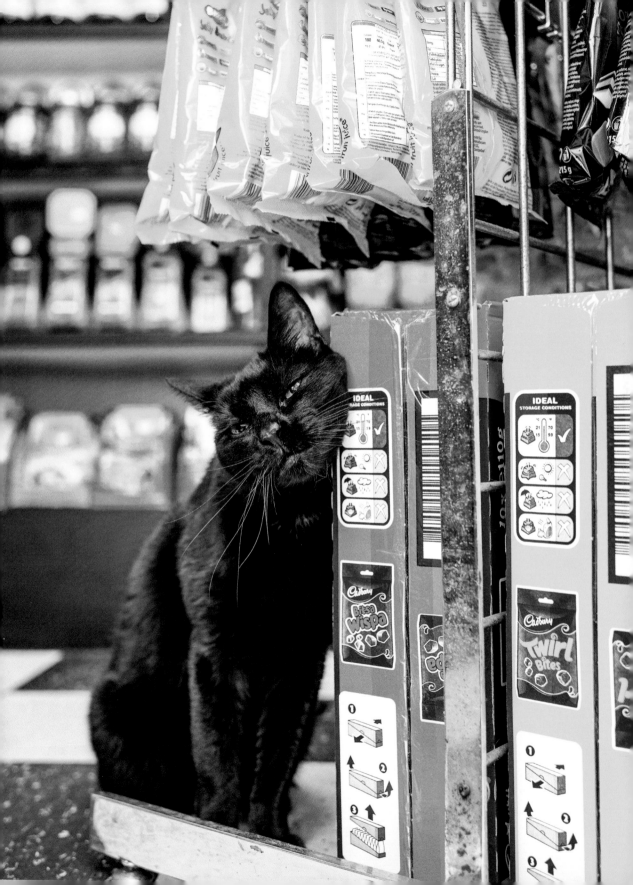

Bud

CHENILLE CLEANERS
Midtown West, Manhattan
Dry Cleaners and Tailor

For a kitty born in the beginning of 2015, Bud (a girl) is already drawing a high-profile crowd at this Midtown establishment.

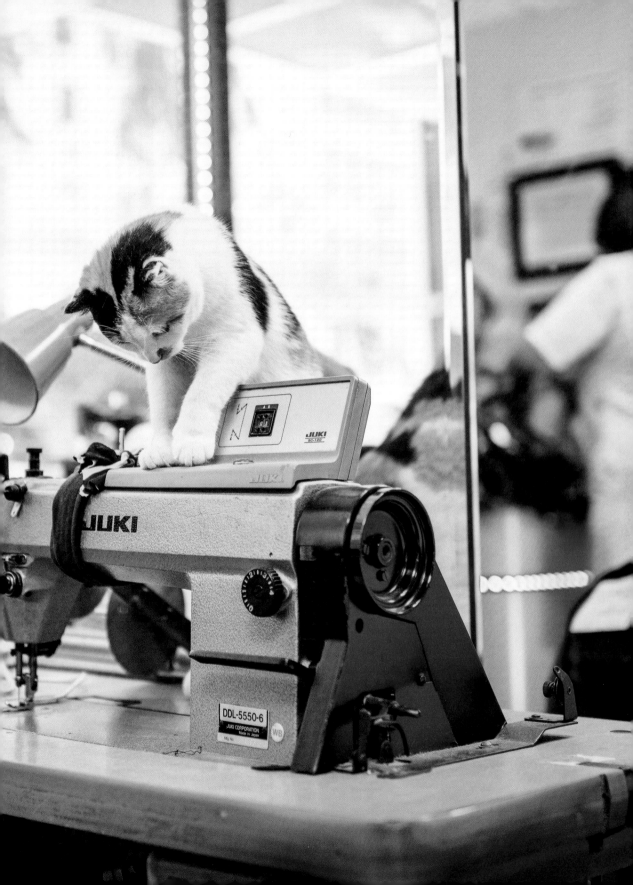

"Recently someone offered me $2,500 for her," recalls Michael, the manager. When asked if he'd contemplated it—if even for a brief moment—Michael is quick to respond, "Nah, nah."

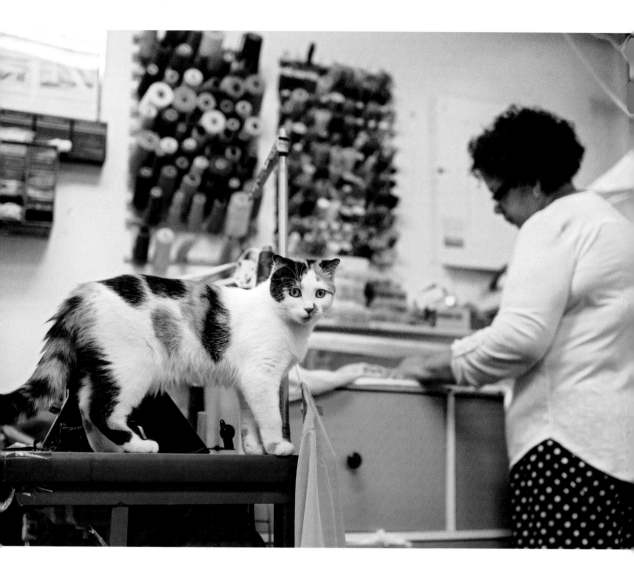

He admits she's a beauty, with the softest fur; she tends to bring in new, curious customers. His only complaint? Cat hair. "I try not to pick her up if I'm wearing dark clothing," he says, though he seems to have an affinity for doing just that. Luckily for Michael, he need not worry about a shortage of lint rollers.

Please
Recycle
Your
Hangers

Boots

FOLIAGE FLOWERS
Flower District, Manhattan
Flower Shop

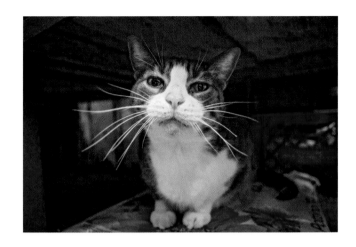

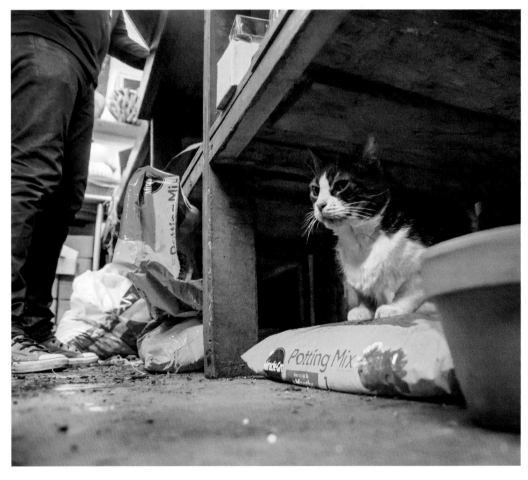

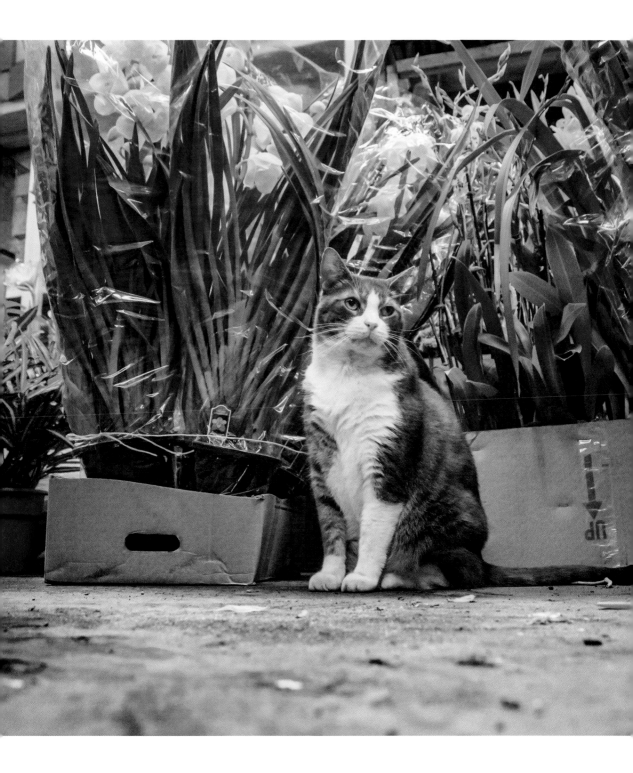

Lionel

RED CABOOSE
Midtown, Manhattan
Hobby Shop

In studying up for my visit to the Red Caboose, I learned *Lionel* is the brand name of a well-known model train company, so it makes perfect sense that the resident cat of this model hobby shop shares the name. I was surprised to learn from Alan, the proprietor, that Lionel is actually "Named after one Lionel Brockman Richie Jr." Better known as Lionel Richie (or Nicole Richie's adoptive father, depending on your age).

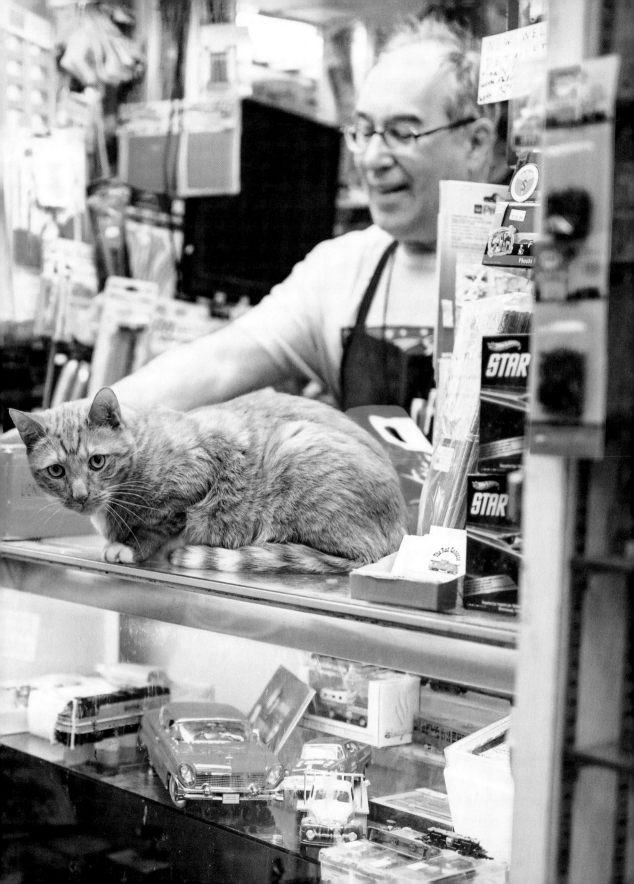

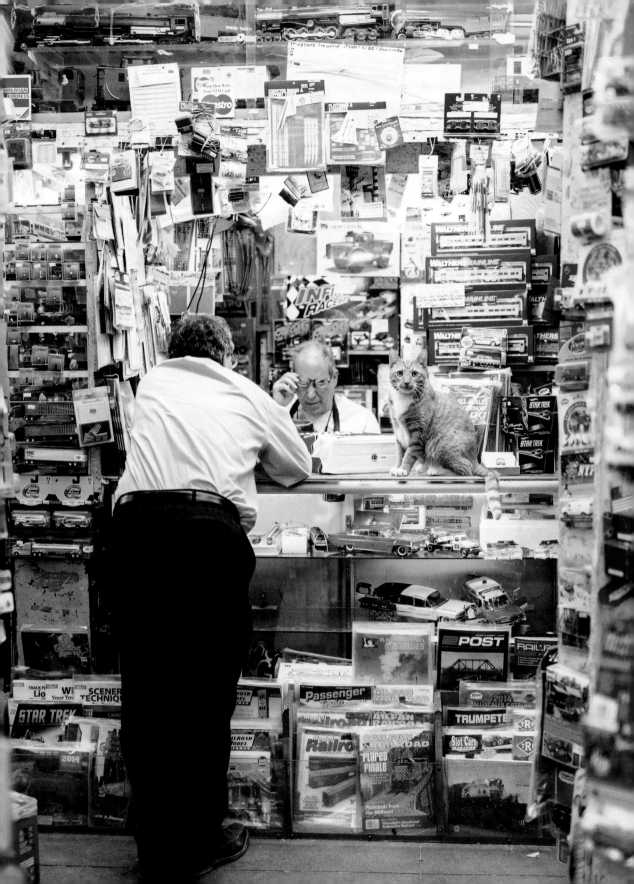

Lionel is usually found at the register of the cluttered hobby shop, which is located out of sight in the basement of an office building. Walking into the store must be what it's like to walk through the wardrobe into Narnia, though instead of a fantasy land, it leads to a dusty, bygone era: glass cases, doors, and rows and rows of wall-to-ceiling shelves straining under the weight of boxed, mounted, or hanging models of cars, trains, buses, and planes.

Lionel's spot at the front of the store is the perfect place for people watching, petting, treats, and—perhaps most important—bubble wrap, which he enjoys trying to wrangle away from Alan. Although Alan works in what he says can be viewed as the often unpleasant business of sales, he considers Lionel, "a good selling feature that projects humanity into something of a churlish nature."

Alan places Lionel's age at around twelve to fourteen years; he's been with Alan for about ten. His health test for Lionel consists of his ability to jump up and off the relatively high countertop unassisted. So far so good.

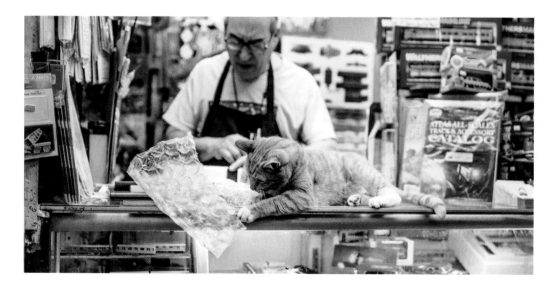

Chloe

WEST CHELSEA VETERINARY

Chelsea, Manhattan
Veterinary Clinic

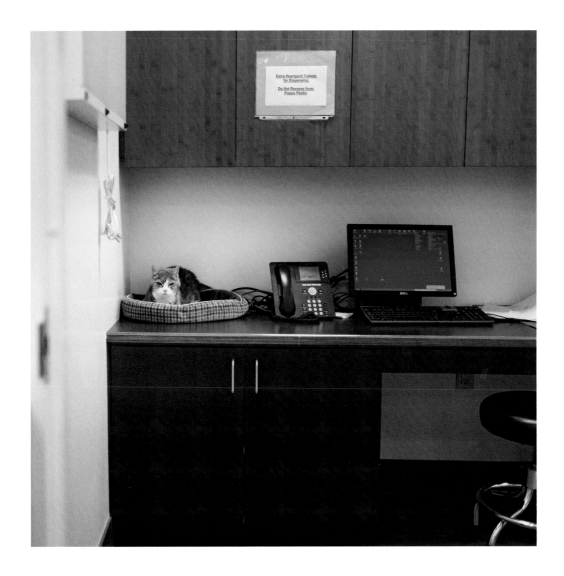

At age seventeen, Chloe had become deaf and meowed loudly, something her owners considered a nuisance. As Liz, the hospital manager, puts it, "She probably thought no one was listening to her." And while her owners considered this intolerable (they gave her up, which is referred to as "owner surrender"), Liz and the folks at West Chelsea found it endearing and decided to keep her.

At first Liz thought Chloe would be the perfect addition to her band of misfit cats at home—a one-eyed cat and another with a deformed foot among them. But Chloe quickly tried to beat up the other cats and was promptly returned to the hospital, which became her home.

"Chloe loves people," Liz says. "She wants everyone's attention on her all the time." And when she doesn't get it, "she follows you around and 'yells.' She's the queen, we're like the court, and we run around to make sure everything is all right with her. God forbid she wants more food. We always know." Liz says Chloe has "the meow heard around the world." And after hearing it in person, I think she may be right.

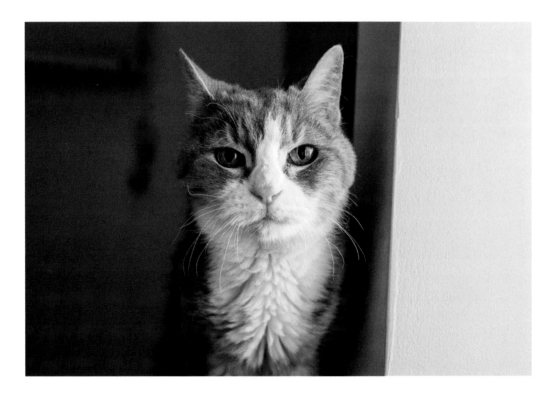

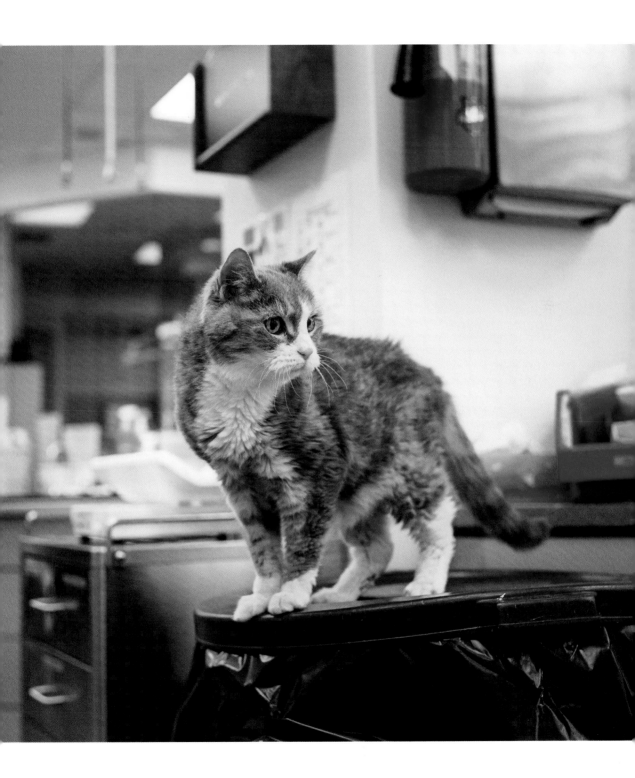

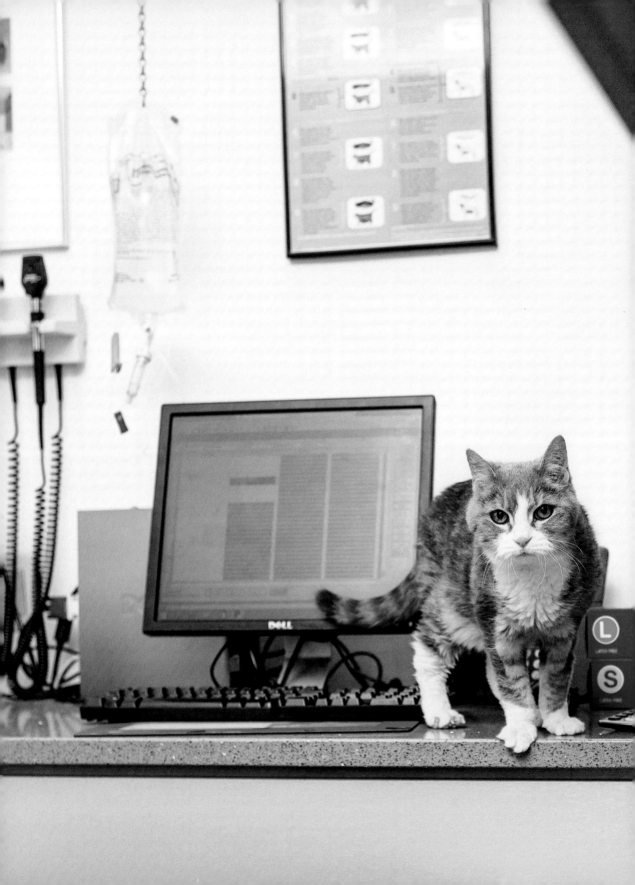

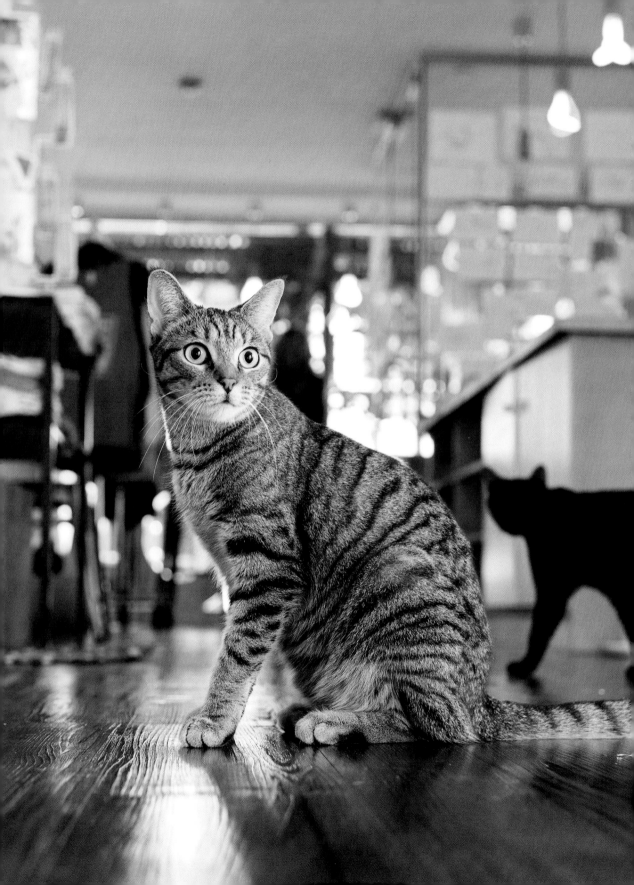

Cats for Adoption

MEOW PARLOUR
Lower East Side, Manhattan
Cat Café

In December 2014 New York City got its first cat café, Meow Parlour, which is sure to be the first of many. Instead of shop cats, we now have a shop *of* cats.

Though Meow Parlour is open to any cat lover, the main purpose of the café is to adopt cats out to local residents.

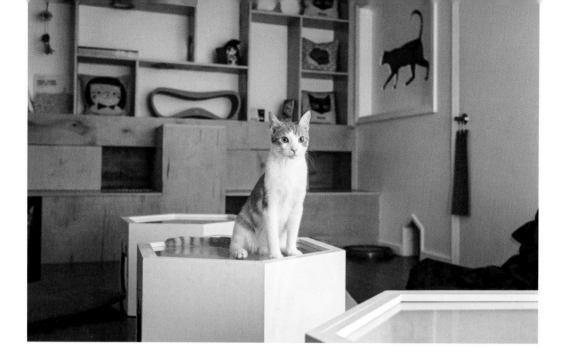

Christina Ha, cofounder of the café, believes the environment plays a large role in getting cats adopted. "Our cats have been through a lot before coming to us, but we serve as a sort of halfway home or rehabilitation center, and part of the rehabilitation for them is to become more social-ized. Each guest that interacts with a cat is helping to socialize that cat and prepare him or her for adoption."

Christina and her business partner Emilie Legrand hoped a less stressful environment and greater amount of roaming space would help the cats become acclimated to human interaction, but they did not expect the incredible effect the café has had on them.

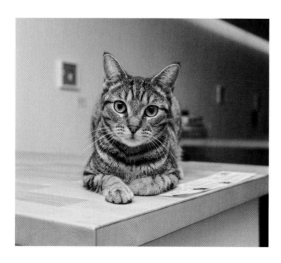

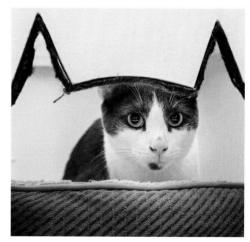

"We had a cat named Carmen who took two weeks to leave her cage, and she would always hiss at us when we made eye contact with her. Six weeks later, she was a really sweet, cuddly, and affectionate cat, and her cute personality got her adopted. . . . This is a story that repeats itself over and over again."

Currently, their most loyal customer is a toddler who lives upstairs from the café and comes to visit several times a week. She's just learning to walk, so we'll see what the cats think once they can no longer outrun her.

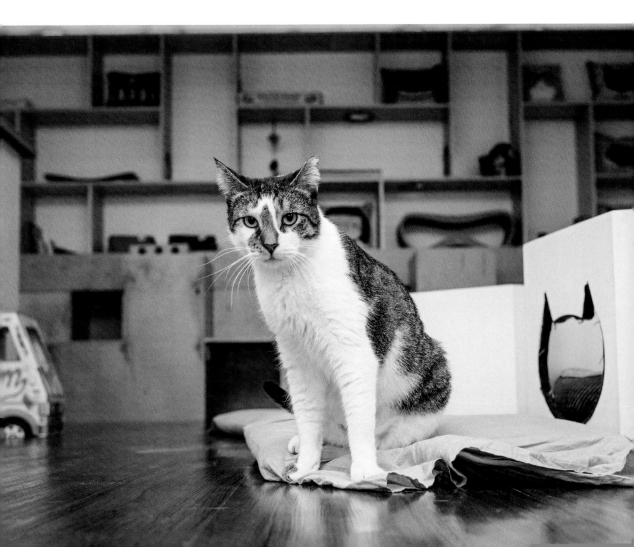

Charlie

SMOKE SCENE

Hell's Kitchen, Manhattan
Smoke and Vape Shop

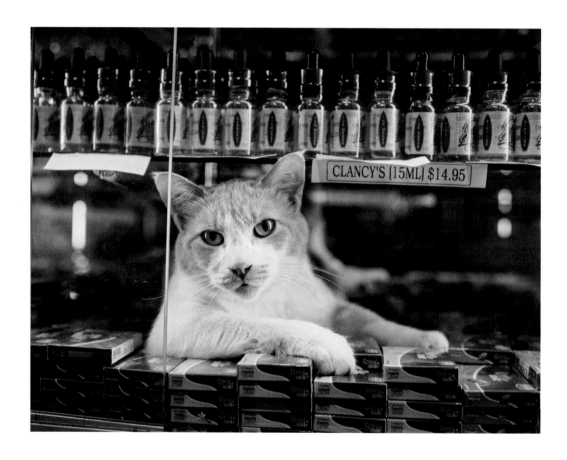

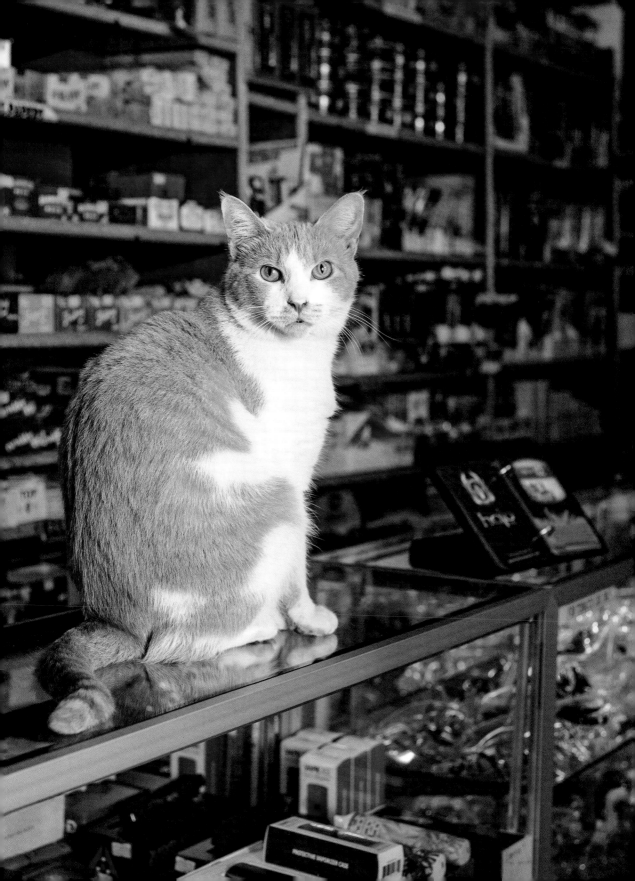

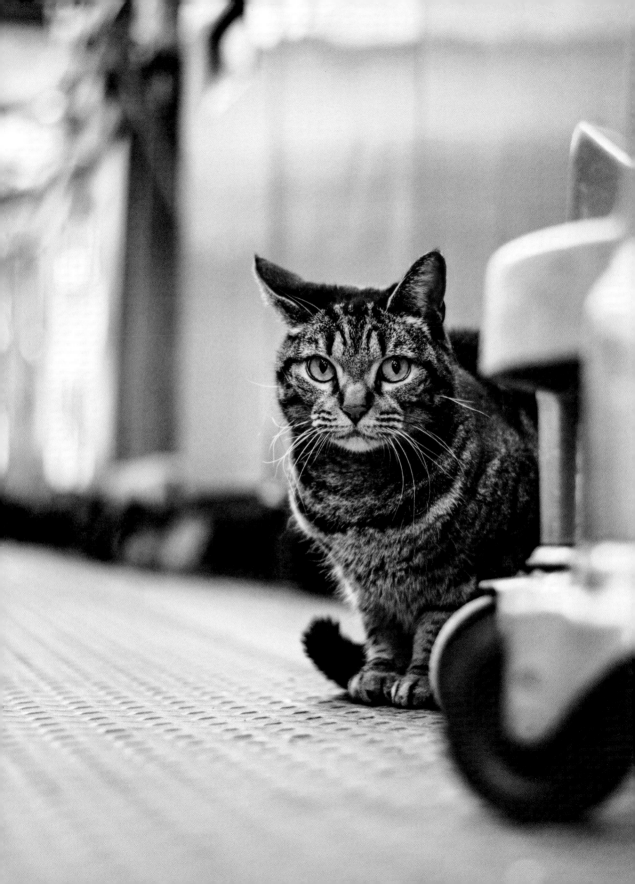

Tiger

QUALITY BOWERY
Bowery, Manhattan
Used Restaurant Equipment

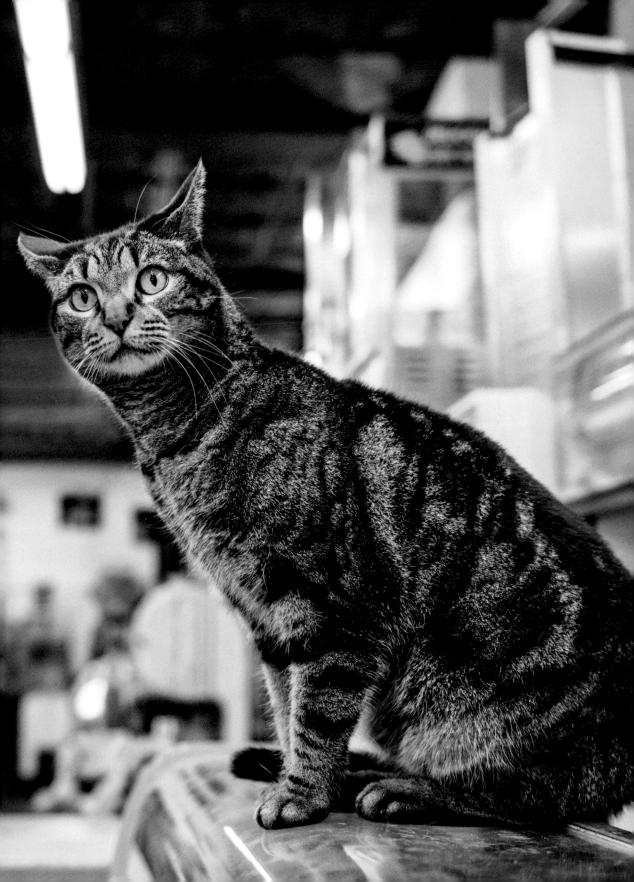

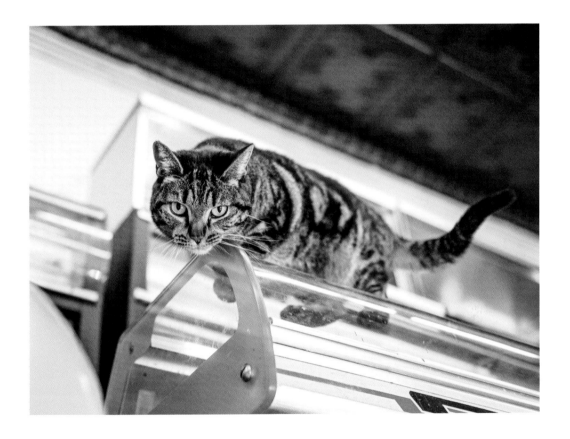

Harriett

SHAKESPEARE & CO.
Upper East Side, Manhattan
Bookstore

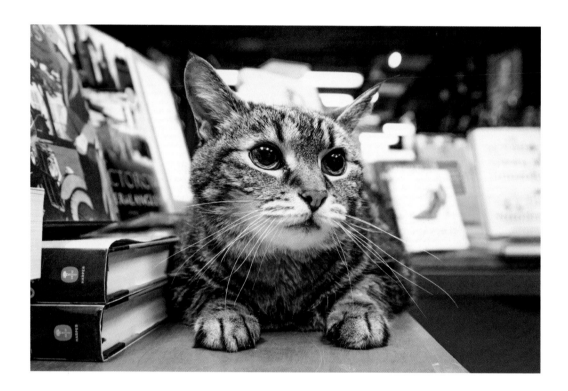

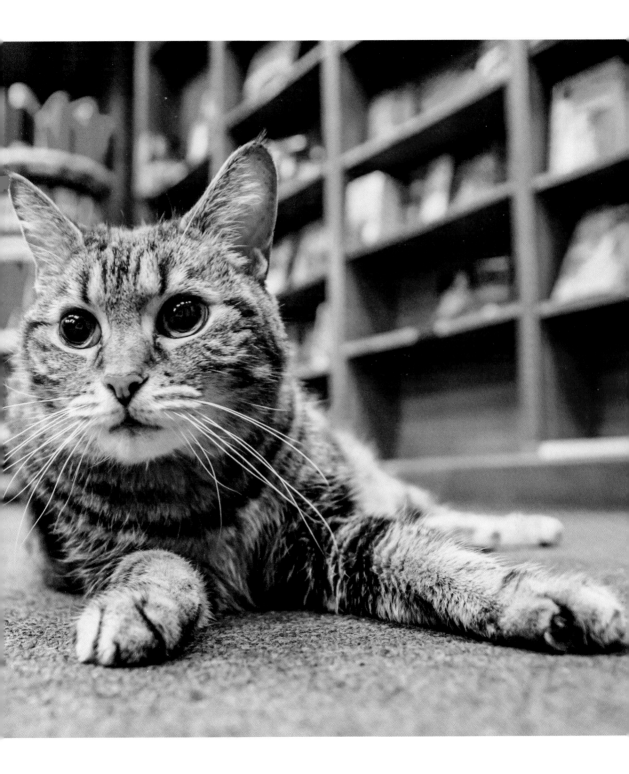

Ric and Rac

DAYTONA TRIMMINGS
Garment District, Manhattan
Trim Shop

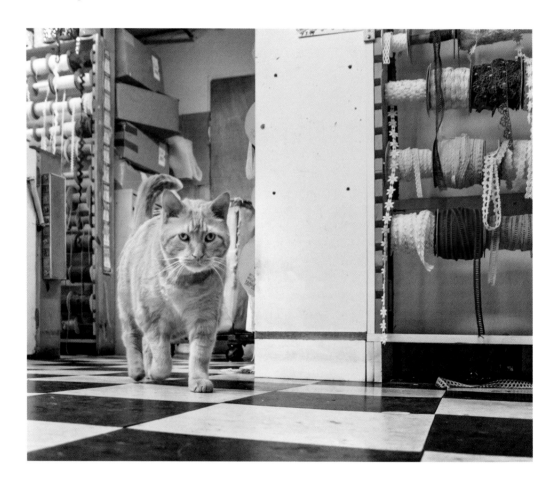

"They're our family," says Nick, the son of the family-owned trim shop where two brothers, Ric and Rac, reside.

Ric and Rac are named after a wide selection of the trim for which the store has become well known. Though the brothers look almost identical, everyone has different tips to share for telling them apart: "Ric's fur is lighter around the eyes"; "Rac is a darker orange"; "Rac has more space between his eyes"; and so on.

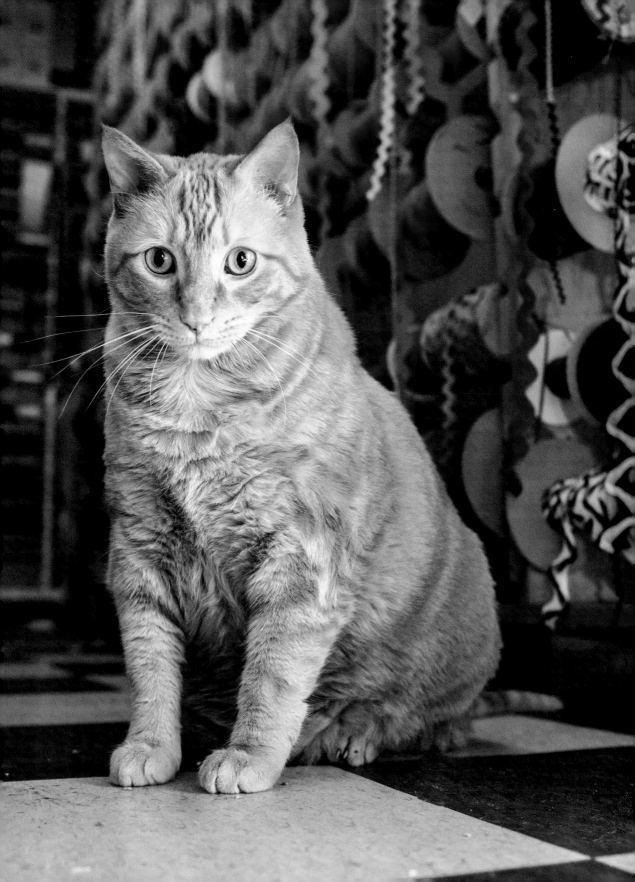

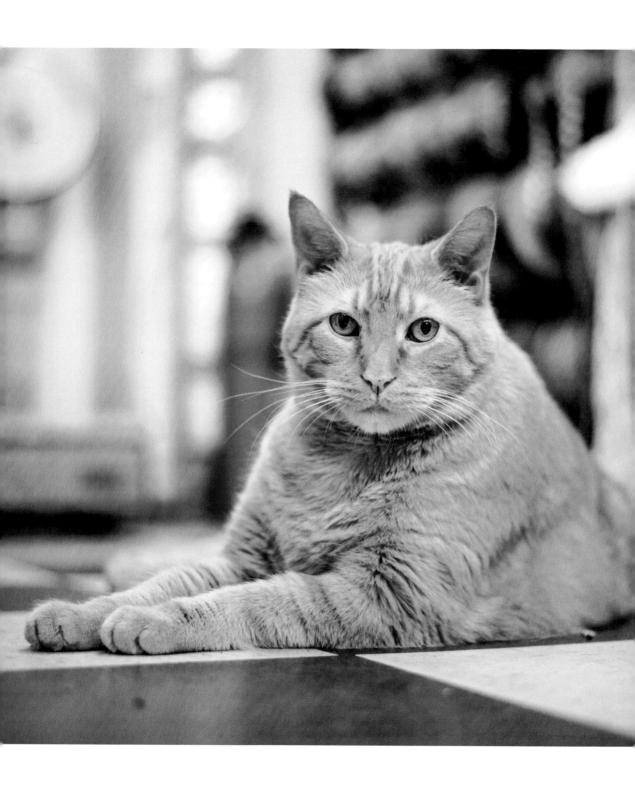

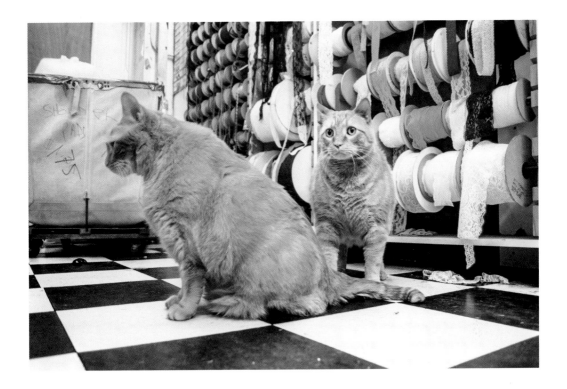

Their likenesses have even been immortalized in the commissioned watercolor of the family hanging in Nick's stepfather's office. It's visible to customers as they go upstairs, where one of the two feline brothers is always at the ready to "assist" customers.

One employee joked that while everything else in the store is sold by the yard, the cats go by the pound.

Nick started an Instagram account for the business so prospective customers could get to know the store, and so he could repost photos of current customers' creations. But, he reports with amusement, "it quickly filled up with photos of Ric and Rac."

Allegra

C.O. BIGELOW

West Village, Manhattan
Pharmacy/Drugstore

A historic landmark in New York City, C.O. Bigelow has a long history of cats going back to its founding in 1838. One of the previous cats was named Mr. Bigelow and he loved the limelight. However, the current cat resident, Allegra, keeps mostly to herself, hiding out in the upstairs office during business hours. Her name is apropos given Ian, the pharmacist and owner, is highly allergic to cats.

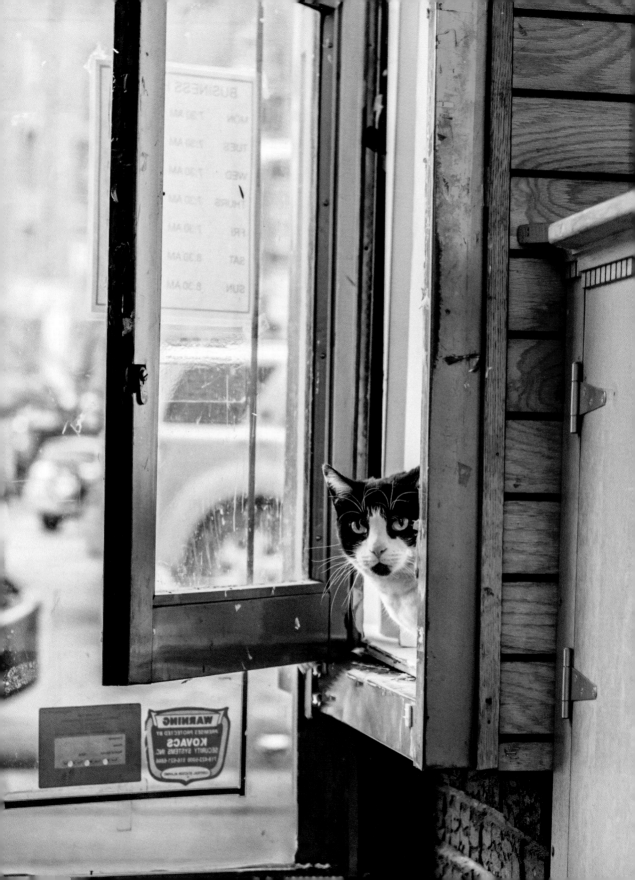

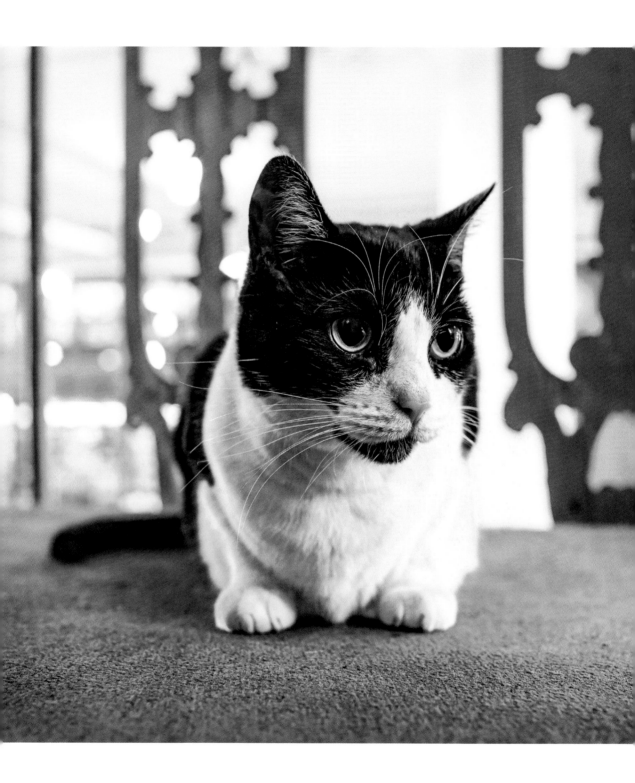

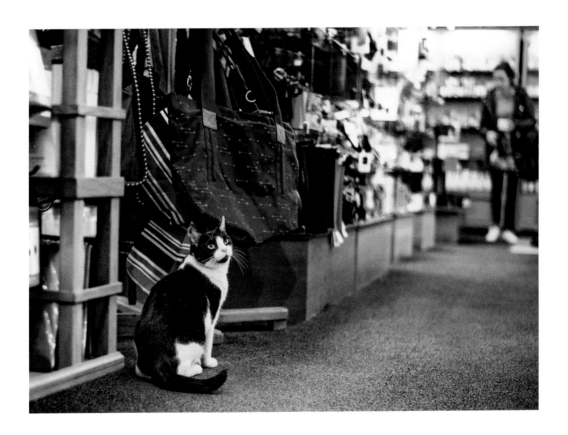

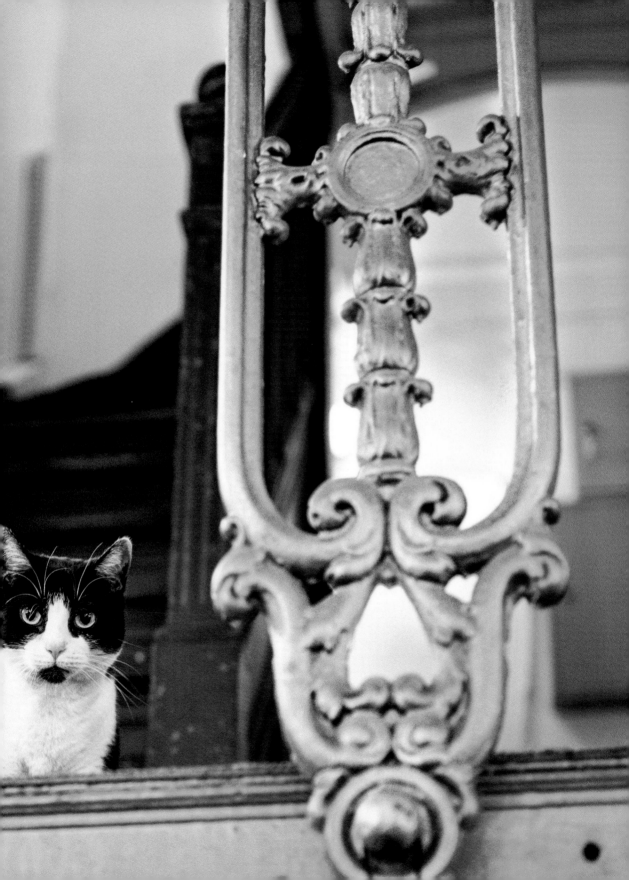

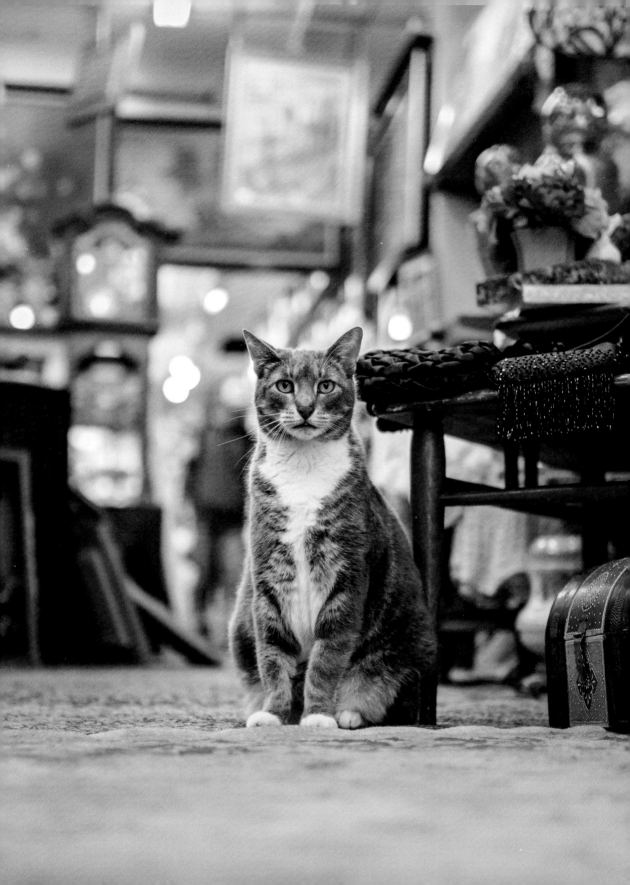

Sava

DREAM FISHING TACKLE
Greenpoint, Brooklyn
Tackle and Home Goods Store

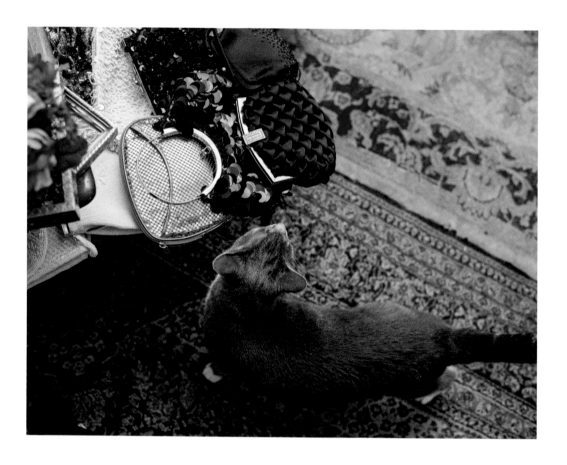

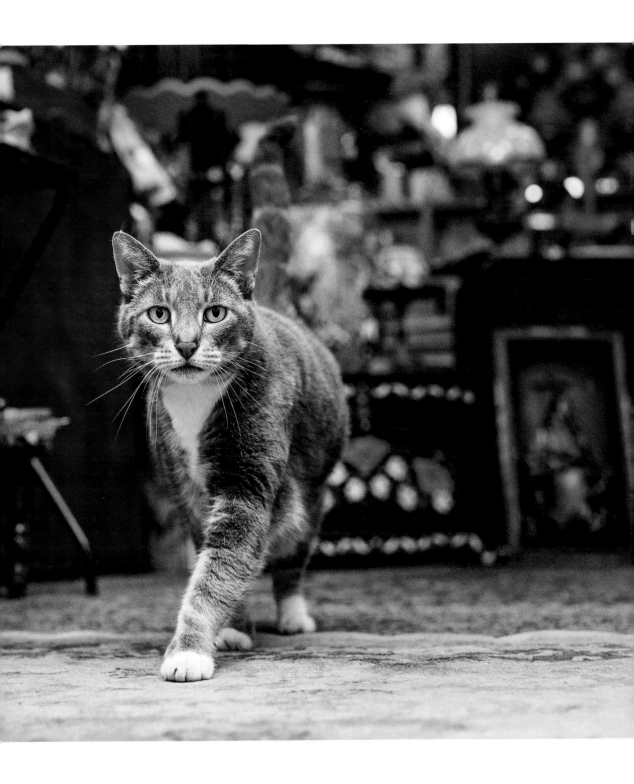

Bobo

JAPAN MARKET INC.
Chinatown, Manhattan
Specialty Grocer

While Bobo is prone to knocking over the bamboo plants and breaking a dish or two, he's exempt from the "You Break You Buy" policy prominently posted on neon-pink paper around the shop.

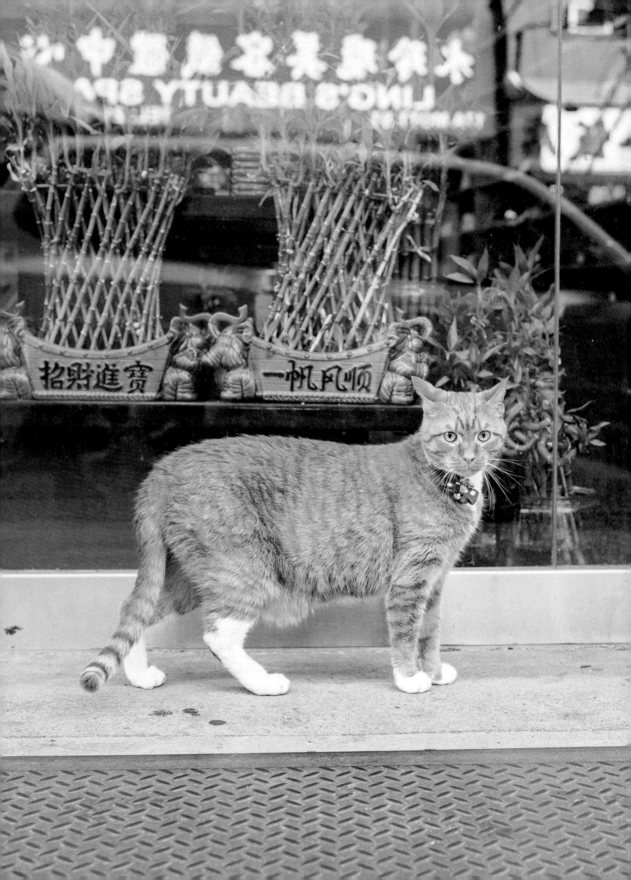

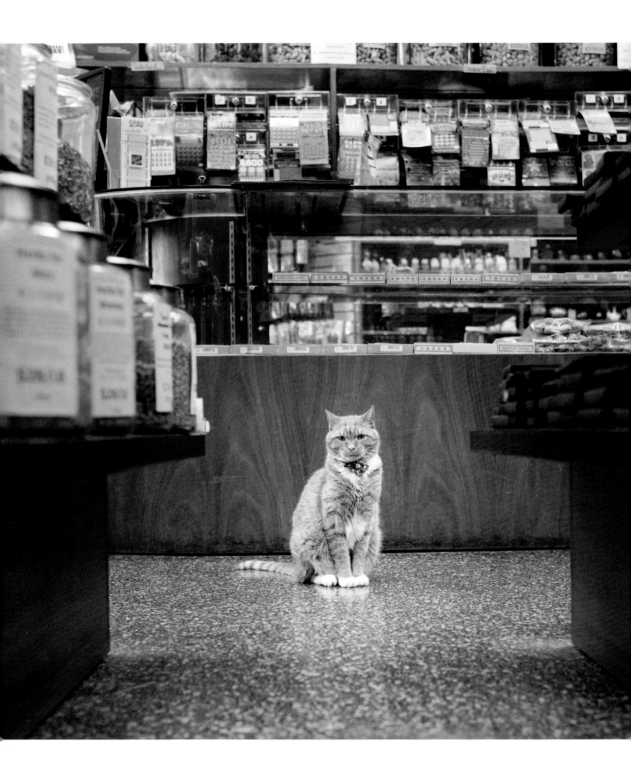

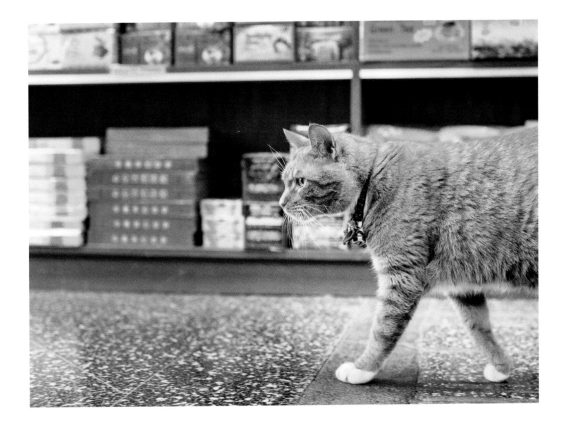

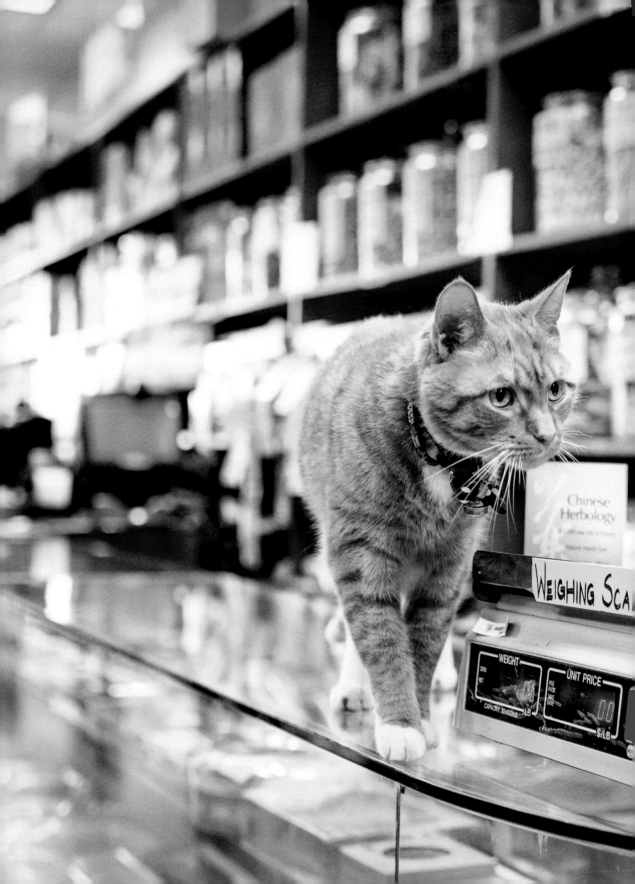

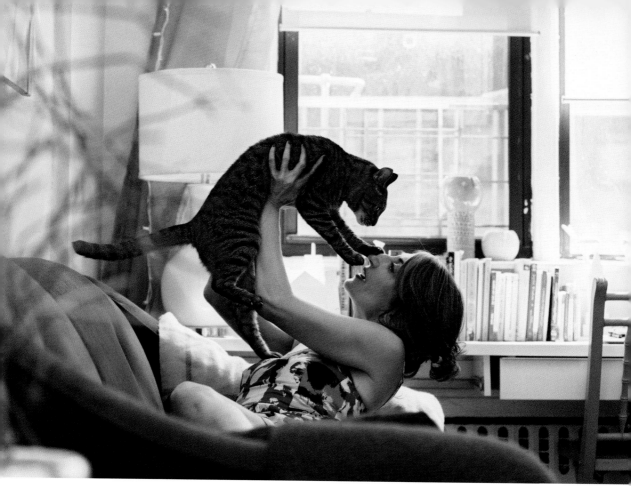

photograph by Jack

Acknowledgments

First and foremost, Andrew and I owe a deep sense of gratitude to the New York City cats who allowed us to come into their homes and disrupt their normal schedules for the sake of this book. Of course we are also grateful to their two-legged parents. We'd like to extend our heartfelt thanks to friends and family for believing in us; to our agent, Lindsay Edgecombe, and editor, Rebecca Hunt at HarperCollins, for seeing the potential in our idea and making our dream a reality; as well as to the designers and copy editors for all their hard work in making the book what you see today.

About the Authors

Tamar Arslanian *(opposite)* is the author of the blog IHaveCat.com, "Single in the City with Cat(s)," and has served as vice president of account management at numerous high-profile New York City advertising agencies. She currently consults pet brands on marketing and social media, writes for numerous pet outlets, and shares her home with three rescue cats: Kip, Petie, and Haddie (in birth order).

Andrew Marttila *(below)* is a pet photographer based out of Philadelphia. Once extremely allergic to animals, he overcame this adversity in his early twenties and now lives with his Bengal Haroun, his favorite subject and best friend. Due to the popularity his photos garnered on social media, he pursued his passion of photography after graduating with a degree in neuroscience.

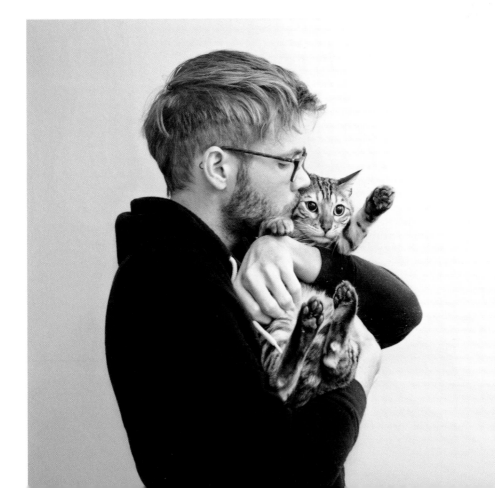

SHOP CATS OF NEW YORK

HarperCollins books may be purchased for educational, business, or sales promotional use. For information please email the Special Markets Department at SPsales@harpercollins.com.

Published in 2016 by
Harper Design
An Imprint of HarperCollins*Publishers*
195 Broadway
New York, NY 10007
Tel: (212) 207-7000
Fax: (855) 746-6023
harperdesign@harpercollins.com
www.hc.com

Distributed throughout the world by
HarperCollins*Publishers*
195 Broadway
New York, NY 10007

ISBN 978-0-06-243202-5

Library of Congress Control Number 2015954935

Printed in the U.S.A.

Cover design by woolypear & Lynne Yeamans
Book design by woolypear
Photography by Andrew Marttila

Second Printing, 2016